Art Classics

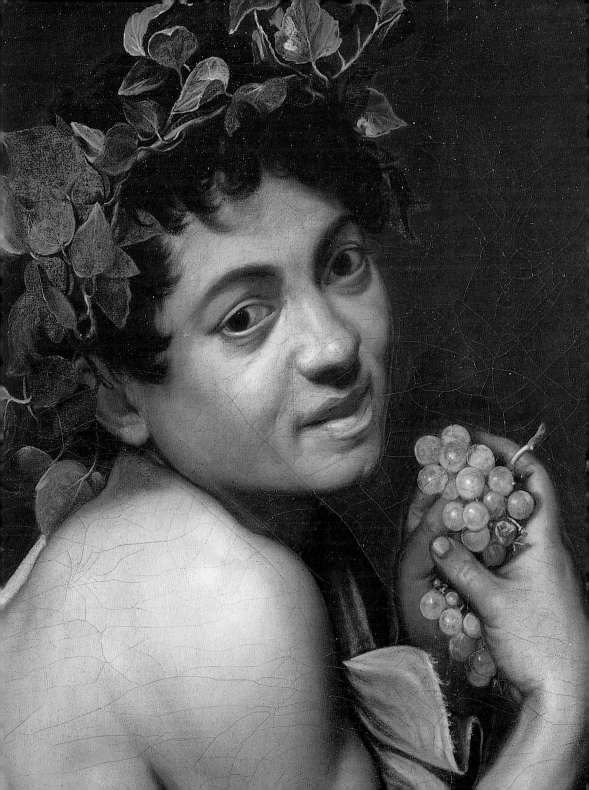

Art Classics

CARAVAGGIO

Preface by Renato Guttuso

RIZZOLI
NEW YORK

ART CLASSICS

CARAVAGGIO

First published in the United States
of America in 2006 by
Rizzoli International Publications, Inc.
300 Park Avenue South
New York, NY 10010
www.rizzoliusa.com

Originally published in Italian by
Rizzoli Libri Illustrati
© 2004 RCS Libri Spa, Milano
All rights reserved
www.rcslibri.it
First edition 2003
Rizzoli \ Skira – Corriere della Sera

2005 2006 2007 2008 2009 /
10 9 8 7 6 5 4 3 2 1

Printed in China

ISBN: 0-8478-2809-3

Library of Congress Control
Number: 2005933784

Director of the series
Eileen Romano

Design
Marcello Francone

Translation
Miriam Hurley
(Buysschaert&Malerba)

Editing and layout
Buysschaert&Malerba, Milan

cover
The Cardsharps
(detail), 1594
Fort Worth, Kimbell Art Museum

frontispiece
Sick Bacchus
(detail), 1593-1594
Roma, Galleria Borghese

The publication of works owned by
the Soprintendenze has been made
possible by the Ministry for Cultural
Goods and Activities.

© Archivio Scala, Firenze
© Lessing/Contrasto, Milano

Contents

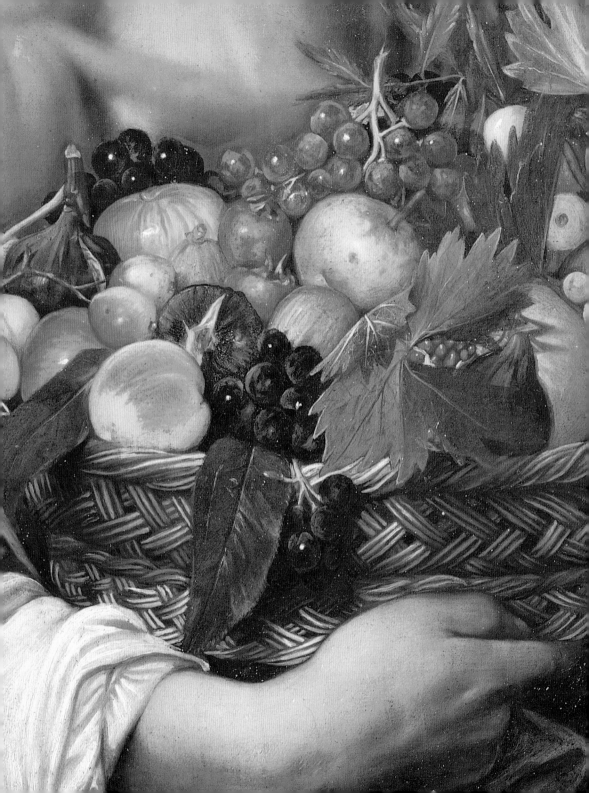

Anti-Academy
Renato Guttuso

How did a young Lombard painter's apprentice come to Rome at eighteen years of age and manage to build himself up, grow and burst out of the lower regions of Piazza Navona, beyond the Tiber, across the Alps, across the bounds of his century and centuries thereafter, to come to be regarded as one of the highest (and possibly the most stable and compact) harbingers for such a disparate range of choices, and contrasting factions, rendering himself the flagship of modernity? How is it possible that to this day, after Kandinsky, after Mondrian, whether it be the most casual passer-by, a Pollock or Rauschenberg devotee, or the most snobbish connoisseur of comic book art who comes into San Luigi dei Francesi, all feel a wound open in their hearts, a wound that they had thought closed forever?

There are questions that have no answer, or perhaps the only possible answer (which many hold in disdain) is that the truth of a great creative passion is measured by its durability, its ability to offer itself up as a living source for new ideologies, conventions, and tastes, always revealing a new face, a face that had never been seen before. Certainly, the young Caravaggio left Milan already equipped with his own core of ideas. He had mastered what he needed with an acute ability for cultural absorption that kept him from any dithering or being sidetracked. His youthful confidence served him as a perfect sifting device, the compass that oriented him and would continue to orient him in future years. His inherent inclinations brought him into contact with the group of 'naturalists' in Lombardy, advocates of simple, realistic, not 'ideal' art.

Boy with a Basket of Fruit (detail), 1593–1594 Rome, Galleria Borghese

Then, there was his trip to Rome. We can assume that on the way he filled his traveling satchels with new acquisitions to strengthen his core ideas. Though we do not know the route he took, we do know what lie in that swath of Italy south of the Po River: Parma, Bologna, Florence, Assisi, perhaps Orvieto; Annibale Carracci, Masaccio, and Giotto.

He found accommodations somewhere in Rome, in the thin alleys around Piazza Navona. It was natural for him to fall in among the young rebels, similar to the world of Lombard naturalists, and that most befitting him. The names of Lorenzo Siciliano, Prosperino, Longo, Leoni, and that of Cavalier d'Arpino, already on the rise in fashion, give an idea of his choice. It was a common choice for an artist freshly arrived in a large city, just as happened and still happens to any eager youth taking off from his hometown to come to Rome or Paris.

In a Rome "of mannerists and painters of grotesques" it was obvious that he would align himself with the latter group. This was true for reasons beyond his temperament or necessity; rather for his philosophies, his dominant philosophy, and his intellectual awareness that in this 'lesser' environment there was more chance to touch the heart of things, a more fertile terrain for the revolution that he held within, than there would be under the dusty canopy of the academy. And even in his scornful rejection of the *grande manière*, which included Raphael (understandably) ("despising the most excellent marbles of the ancients and the famous paintings of Raphael." [Bellori]), he could not fail to realize (as many passages in his work attest) that Raphael was not a 'Raphaelite.' Caravaggio must have noticed the conceptual relationship between Raphael and Masaccio; and, as a result, he could not exclude him, on principle, from his creative experience.

T he last decades of the sixteenth century were ones of great ferment, replete with innovations of extraordinary importance for the formation of modern consciousness. These years saw the death of

Michelangelo, the birth of Galileo, and the Council of Trent closing its work. It was at this point in history that Caravaggio lit his fire. The seemingly artisanal action of painting fruit or flowers would require a quite extraordinary moral power and would become a weapon for renewal, a (quite irrefutable) proposal of a new realism. It was not a matter of advancing a theory. It was about affirming the objective meaning of new contents and new forms, of painting tied closely to real things, born of observation, undivorced from reality.

After Giotto and after Masaccio, he reaffirmed the principle that, rather than abstract concepts or prefabricated philosophical conceptions to be stuck on canvases, what was needed was the consciousness of reality, of things as they are, investigated and explored in their relationships between place, space, and light. Things on their own express ideas, philosophy, and history because these things unleash the 'present' and its sound, the new human condition, the new concrete relationships between people and between people, things, and history.

The paths of realism are not infinite. It is an important point that in the late sixteenth century the point of departure towards realism was still life, the painting of objects. The same thing would happen during the revival of realism in the last decades of the nineteenth century: Courbet's famous subjects 'flowers,' 'trout,' 'pears,' and Cézanne's perseverance with a bag of apples, were in many ways cousin to 'those two coins of fruit' that Caravaggio painted in the front of his *Sick Bacchus*. This was the origin of a revolutionary concept, the dismantling of the hierarchies of subject, the choice of painting 'without an apparent subject' and without 'action'. The best approach to truth is to strip it of its myths, ideologies, and false decorum. This was the only path to a proper, modern idea of 'action' and to a new living enactment of *historia* painting. Under Caravaggio's hand, the *historie* would come, and we know just how violently he would offer them up.

As is wont to happen, his work was accused of being plebian. Yet this

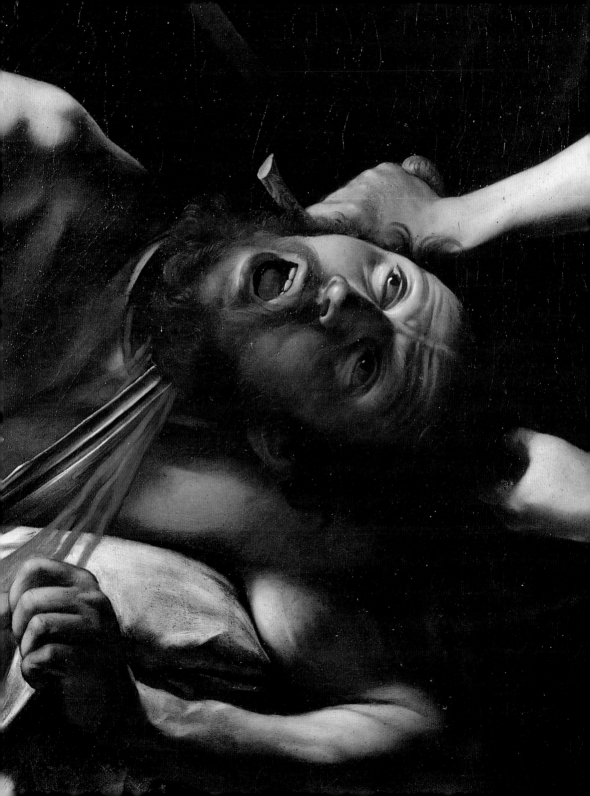

*Judith
Beheading
Holofernes*
(detail), 1599
Rome, Galleria
Nazionale
d'Arte Antica,
Palazzo
Barberini

was no case of a plebian revolt, nor was it an intellectual proposal of popular art in opposition to official art. On the contrary, the basis of his revolution is the thorough knowledge of art, facts, works, schools, and the discourses of the day; his was a superior cultural and historic awareness. It has a popular soul, but is not plebian. It is of one who has understood the source of truth from which to draw: touching earth to draw sap and blood out of it. It is certainly noteworthy that it was Géricault and Courbet to pull Caravaggio up from the museums' basements; and that, before them, David used a Caravaggesque approach, taking the gesture of Martin d'Auch in *The Tennis Court Oath* from Caravaggio's *Saint Matthew* (and confessing in these early years to have been attracted by Caravaggio's works, "*brutalement exécutées, mais pleines de mérite*" roughly executed, but full of merit).

It is noteworthy that during the sixteenth and seventeenth centuries there was a total lack of attention towards Italian art, with almost no critical or historic texts; it was the artists who sifted through false, incomplete, simplistic information and rumors to find their antecedents and pursue the consequences themselves, introducing cultural elements of conceptual connections with other undertakings born of the same need.

His path, which took him to Rome, was similar to that of many others. Without money and very poorly dressed, poverty, illness, recovery in the hospital for the poor; jobs here and there in workshops with this or that painter, heads for a gross each, copies and so on, just to live and badly at that. He also painted, from his own ideas, still life and genre paintings, half figures of brief subjects "cut short," "not even worth titling" [Longhi], street subjects. This became his revelation: his mythological figures, and later his saints, would not descend into his studio from any Olympus, from any empyrean. They would be the people whom he frequented in his youth and throughout his life, because the world is sprinkled with gods, saints, and heroes in the streets, houses,

11

stadiums, in workshops, and inns. His malevolent biographers and historians of the era, no matter how vehemently against him, had to realize that the young man had the devil in his body. And the subject? Everything is a subject. The *historia*? He does not need it. The academic rules of composition? Useless. A complex scene can be structured through the movement of an arm, the tilt of a head, a swing of fabric folds. Each part contains the general structure within it.

These are processes in which apparent simplicity is matched by an imaginative yet controlled development, a science of rhythms, agreements, correspondence between spaces, a skilled distribution of accents, and extremely alert and sensitive *disegno*. His painting was not rough, not incorrect, not improvised. And some people realized this, given that Caravaggio won out over many established 'masters' when he was scant more than twenty years old and obtained a large commission for the Contarelli Chapel in San Luigi dei Francesi, with his work alongside Cavalier d'Arpino, in whose workshop he had been an assistent not long before.

Here Caravaggio was faced with the task of painting *historie*. The problems started straight away. His Saint Matthew "had neither decorum nor the appearance of a saint, they said, as he was sitting with his legs crossed and his feet rudely exposed to the public." They say the painting was rejected, though it is hard to explain how, after such a rejection, Caravaggio came to paint for the same chapel the *Calling* and the *Martyrdom of Saint Matthew*, which, was not in the original contract, and would replace a commission of frescoes assigned to d'Arpino.

The first *Saint Matthew and the Angel*—destroyed in the war, in Berlin, in 1945—was his first foray onto the field, his entrance in 'public' art. The contrast in the painting between the saint, who is absolutely earthly, and the angel, who is gently mannerist, takes on ideological significance. Matthew is a man like those Caravaggio saw and knew; but the painter does not know what an angel is like, he has to imagine him. And while he

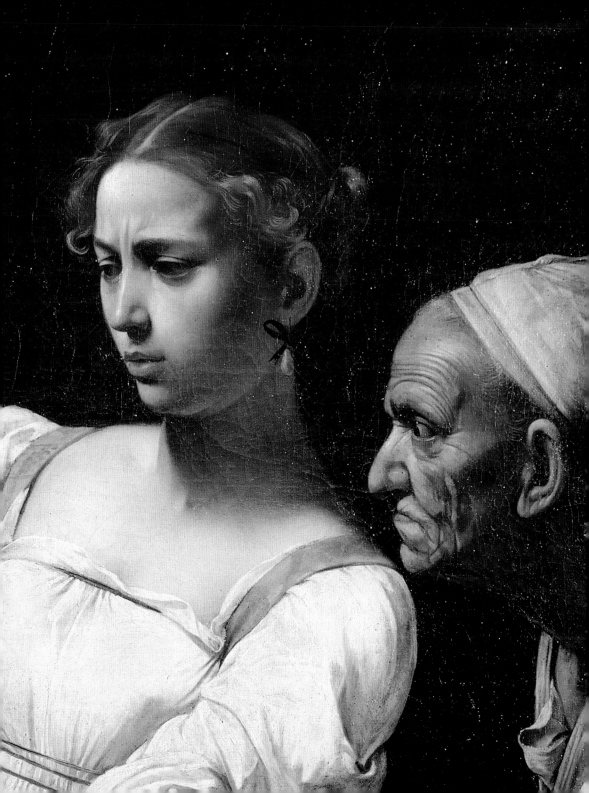

gives him the features of a young boy, he does not seem to convince even himself. The effeminate angel sidles up to Matthew, slips out a shapely arm to guide the heavy peasant hand, which seems like the hand, of one who does not know what to write, the hand of one who does not know how to write. An ambiguous violence, a new fascination, is born of the contrast of statements, earthly and celestial, from this intersection and linking of heterogeneous forms.

It is more probable that he himself wanted to replace it after the completion of *Calling* and the *Martyrdom* out of a desire to give balance to the chapel as a whole. In my opinion, the second *Saint Matthew and the Angel* is a painting of connection, less intense than the other, though definitely more refined and less provocative.

Caravaggio spent a decade of fervent creativity in Rome that made him a *celeberrimus pictor,* as Ruggero Tritonio called him in 1597. His field of action suddenly expanded; he roamed it without contradicting himself, specifying the terms of his thought, making these terms increasingly convincing as he gradually achieved the ability to integrate his cultural contribution into a historic context.

Needless to say, the commission of *historia* works posed him new problems. Caravaggio had to take these problems into consideration; however, the important point is that these problems were not 'put straight' following the taste of the time. He took on a more somber painting, with stronger signs, giving depth and cleanness to the darks, without disowning or adapting his ideas. On the contrary, he reaffirmed his thinking within a realm of wider action. He invented an entirely new structural function for light, almost a third element next to drawing and color (Longhi compares the importance of this to the discovery of perspective in the fifteenth century), a new emotiveness of spatial relationships, to create the 'tumult' of a balance of right angles (the use of the square within the compositional

structure) rather than the Michelangelesque spiral pyramid through which the mannerists set the rules. An intellectual work, the real and total construction of the space, which he laboriously specified, changing many times his mind, destroying his work and starting over again. If he realized that he had given in to a sixteenth-century mechanism (the first version of the *Martyrdom* which we can see with radiographs), he immediately took apart the composition and redirected it towards the first intention in a courageous act of artistic consistency and artistic ethics.

The *Calling of Saint Matthew* is a key painting in the history of art. It is Caravaggio's real 'explosion'; a painting in which all aspects permeate one another and are interdependent, where the choice of a scene torn from daily life—by no means a random choice—is actualized through the constructive and meaningful use of light. (It would be precisely meaningful light that would fascinate Caravaggio and create the cloak of the apostle who hides Christ, a rather mannerist invention).

Of course, for the academics and the stuffy cultural bureaucracy of the age, only 'incompetents' could praise these paintings. The prince of painting of the time, Federico Zuccaro, had much in common with those times, and came out with the famous statement reported by Baglione: "What is the fuss about? I do not see anything here but Giorgione's conception […] and sneering […] and marveling at all this excitement he turned on his heel and left." What did the Academy want to prove? That Caravaggio was nothing new, no more than vulgarity, and that when it came to style he was backwards, already surpassed.

following
pages
Deposition
(detail),
1602–1604
Vatican City,
Pinacoteca
Vaticana

This was a superficial and unrefined judgment (the only relationship with Giorgione is in the feathered hats and the lansquenet's clothes). But the scene recalls other, deeper comparisons (to Masaccio's *Tribute Money* in Carmine in Florence, for instance it is in the same wellspring of truth in which both had dipped their hands).

Caravaggio cared little who Matthew of the gospels was. He just wanted

15

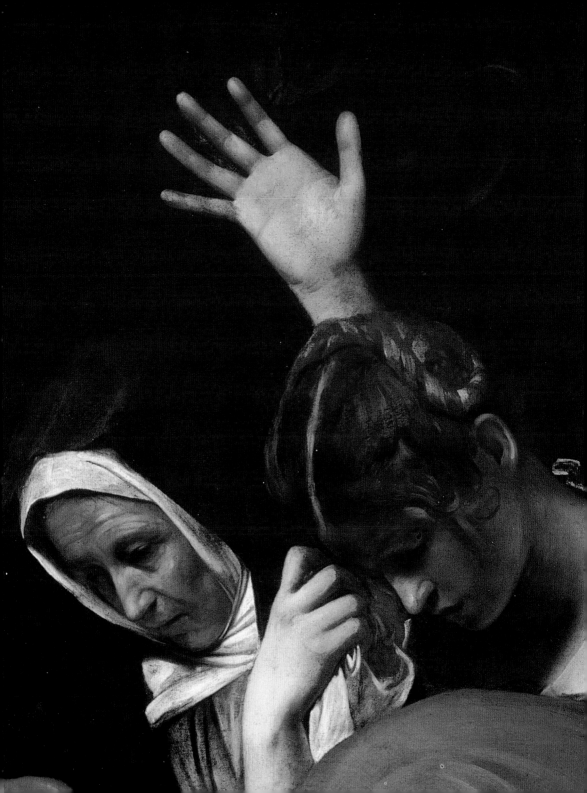

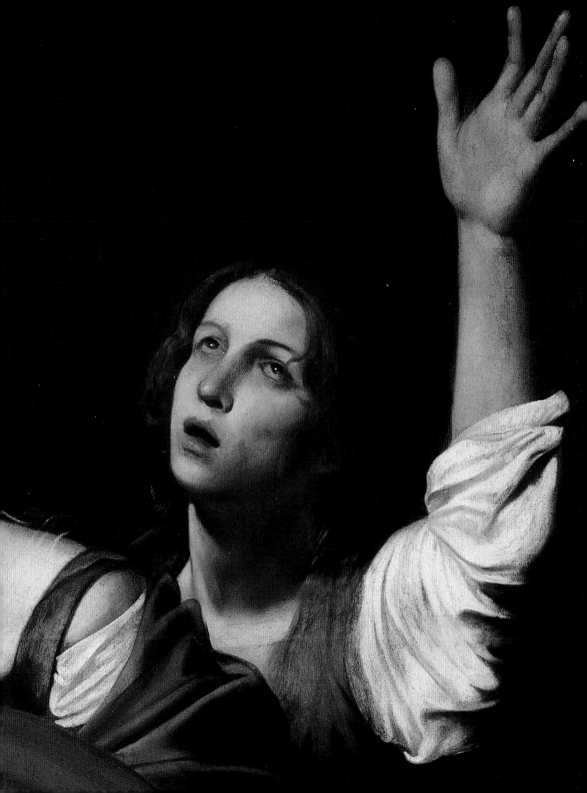

to know that he was a man called while he was going about his regular day. And, in order to recount it, Caravaggio used a scene familiar to him, a theme that had always interested him because only through that which is familiar and known can he tell about the truth, rather than by building a little theatre set based on traditional texts and notions. Man reads, thinks, and imagines, but everything that he touches lives only in relationship to the present, to what he knows; the stories of the past, faraway, unknown places, can only be returned to life through that which is nearest, that with which we are familiar—houses, objects, actions, and feelings.

In *The Conversion of Saint Paul* in the Cerasi chapel, Caravaggio constructed the composition of a square in the vertical rectangle of the canvas. Saint Paul, on the ground, raises his hands: dazzled, we would guess, by the enormous luminous mass of the horse's body. In *The Crucifixion of Saint Peter* there is again a square in a rectangle. Yet, formal discoveries and inventions are always a function of 'telling things.' A vine leaf can crumple in the same way in which Saint Matthew's forehead creases because he worked as hard to "make a good painting of flowers as one of figures." This is not a formalist theory and this is not an artisanal theory. It is the concept of a *valent'huomo* (Caravaggio said, "Thus in painting a *valent'huomo* is he who knows how to paint well and to imitate natural objects well"), of one who does the art of painting well; an art through which life is generated, vital impulses are inspired, ideas and concepts are signified and reality is revealed.

You might think that biographers did not know how to tell the history of Caravaggio except through the stories of the rejections of his works by this or that confraternity. Yet, clearly, as soon as a painting was rejected, someone else took it back up. Commissions came pouring in. As wild and messy as Caravaggio's life was, between brawls, sword blows and escapes, there was a succession of ambitious works that were scrupulously executed.

What the ancient theme of *The Death of the Virgin* became in his

The Martyrdom of Saint Matthew (detail), 1600–1601 Rome, San Luigi dei Francesi, Contarelli chapel

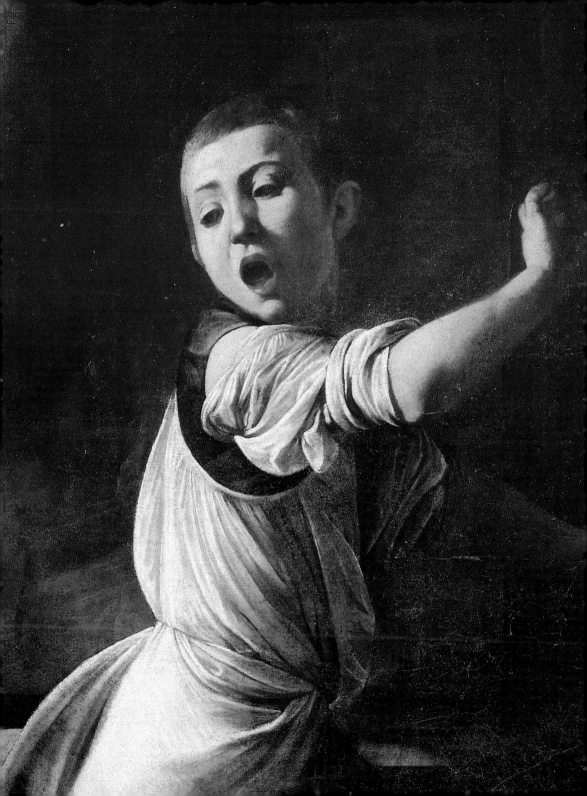

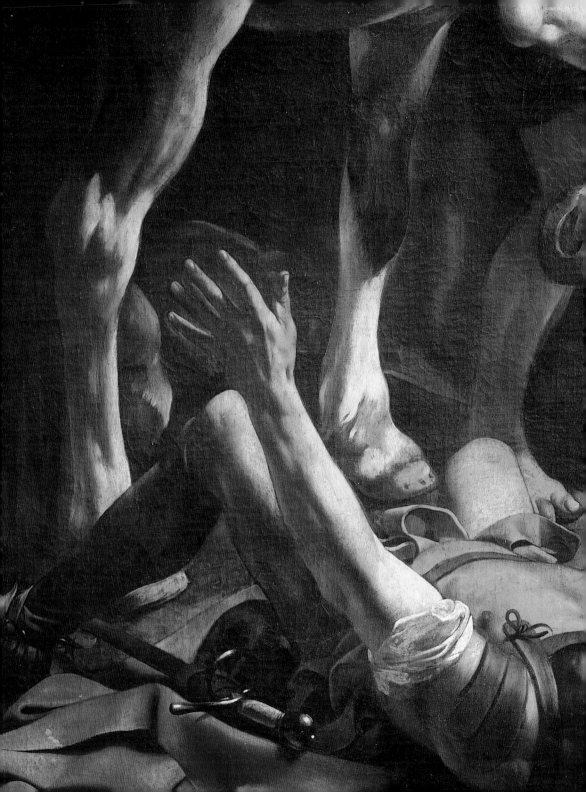

hands! A regular scene of grieving taking place with family and friends, made of the real sorrow that the death of a mother brings to any home. How is Christ about to be deposed in the sepulcher? Who else had ever thought to construct such a scene in this way? Here again, there is no expressionism nor forcing of theatrical attitudes. The only 'gesture' is of the figure of Mary of Cleophas who raises her arms to the heavens; it is a classic gesture from Greek tragedy. Everything is resonant, marked, concrete: gestures, feelings, space, volumes, and color.

Though it can be inferred, we do not know what Caravaggio's relationship was to the ideological disputes of the age. Regardless, we can reject the interpretation of his work from the perspective of the Lombard Counter Reformation. Caravaggio is certainly closer to the thinking of Giordano Bruno than that of Saint Charles Borromeo.

Caravaggio dealt with sacred material in his own way. His conversation with reality did not allow him to reiterate any pre-established schema. Lombard or Roman, sumptuous or severe, the Counter Reformation painting 'mechanisms' all looked alike, expressed the same ideology, intentionally edifying and admonishing; Caravaggio's art is far removed from such an attitude. It should also be noted that in Caravaggio, the common people are not, as they are in Lombard Counter Reformation painting, praying, unhappy spectators, burdened plebeians towards whom the painting turns a gaze of charity. They are the protagonists. They become the dead Christ, Saint Matthew, the Madonna, Saint Anne, and so on.

Caravaggio's glory and wealth grew and, with them, envy; his conviction grew and, with it, the malice of the Pharisees. Caravaggio's soul hardened, but he did not change his style, or his life; amidst obstacles and conflicts of all kinds, he painted and continued to frequent his people, until a brawl at a tennis game ended in a man being killed. Caravaggio fled to Naples; this time not temporarily.

In Naples, he was immediately full of commissions. Over the course of a year, he painted some memorable works without objections from clients and without personal incident. One of these was the *Flagellation* for San Domenico. It is a superior painting, stark, composed with absolute simplicity, with a compositional structure entirely made of things 'to be told.' Two executioners, stevedores, prepare the victim. A light emanates from His body, a whiteness of human flesh, as He had never given in painting, a mass of pure white that is about to collapse, the white fleece of the Agnus Dei, which in contrast (contact) with the muscular masses of the lepers generates a shocking burst of truth.

Another memorable painting: *The Seven Works of Mercy* in which Naples appears as it was, and as it is, with its chaos, its action. A painting that is as dense, diverse, and adventurous as the city itself.

He then ventures from Naples to Malta. (Perhaps sent, or encouraged by some random meeting. Certainly not "to have himself knighted".)

The most important work that he painted in Malta to be included in any thorough Caravaggio anthology is *The Beheading of Saint John the Baptist*, in which many conceptual conflicts were overcome and which buried many commonplaces (realism opposed to classic spirit) and many futile cultural disputes. As in some passages of *The Seven Works of Mercy* (the Madonna looking out on the balcony at night, the commoner who gives her breast to feed the prisoner), Caravaggio's high classical spirit resounds in this panting—his encounter with the best of Raphael—and there is a hint of Greece and Pompeii (pieces seen in Naples or an unconscious concurrence of intentions?).

But an unruly nature, and possibly one glass too many of Maltese wine, can suddenly put a man in jeopardy, even if he is a knight (of Honor and Devotion). When this is the case, we will find a greater knight (of Justice) who will find a way to drag him in prison. He escaped one night and took refuge in Syracuse, where another of his most awe-inspiring paintings came

to be: *The Burial of Saint Lucy*. Of those we know from the history of painting (I would mention El Greco's *Entierro del Conde de Orgaz* and Courbet's *Enterrement à Ornans*), Caravaggio's *Burial* is without a doubt the most tragic, everyday, and real. A burial like this, with people like this, a nighttime burial in the courtyard of a prison; two thirds of the canvas covered vertically by an impassable wall that rises without incident, a latomy wall bordered only by a dark arch, whose space plunges left to the curve that soars to the upper corner of the canvas and is stopped on the bottom by the clot of light on the massive shoulder of the gravedigger. Despite its stronger tragic feeling, it is quite close to the *Beheading* of Malta. It has the same idea of a large space united above, just barely touched by whiffs of a story. A space that generates an uncommon relationship with the figures, manipulated in an absolutely new and free manner that rejects compositional precepts, just as, in an opposite process, he had nullified them a year earlier with *The Seven Works of Mercy*.

After Syracuse he travels to Messina and Palermo, always leaving works in his wake. Until his death on the tragic Tyrrhenian coast that also holds the bones of Palinuro, Shelley and Nievo.

Rome did not know how to understand this death any more than it did this life. For centuries, it relegated the extraordinary revolutionary opportunity that Caravaggio's work offered to the shadows. From that point on, it was up to rare new individuals, solitary and dedicated creators, to take up the threads of that opportunity and pursue the idea of painting as an affirmation of the truth of things, as consciousness of life and death.

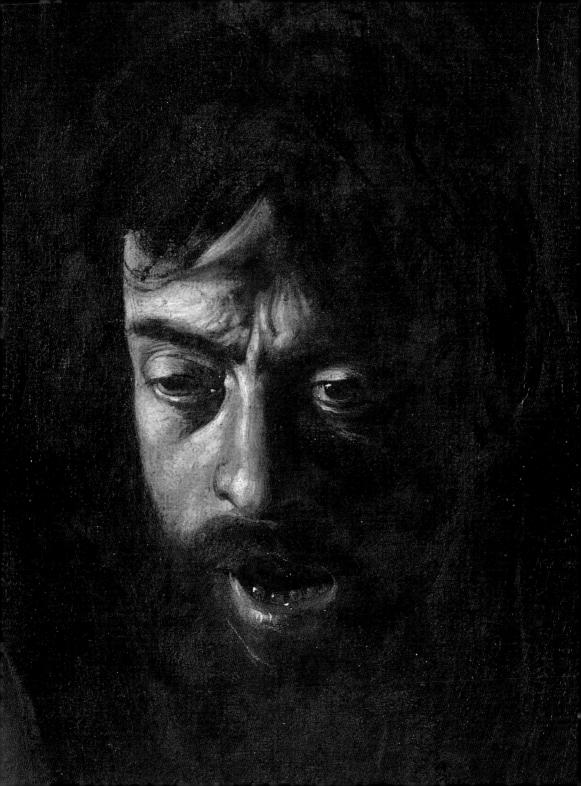

His Life and Art

Caravaggio was a violent, murderer man and the brilliant protagonist of a tormented life spent amidst luxury, the great refinements of the Roman palaces of seventeenth-century princes, and the lowlife of the street amidst thugs and prostitutes. This is the well-known legend of Michelangelo Merisi, known as Caravaggio after his native town; it is a legend crafted by biographers who, however, never lacked for material.

Today, stripped of any impartial intentions and through the wealth of discoveries and studies on Caravaggio, we are left with the story of a personality who was faithful to principles that were, in fact, less against the common mores of the day and more against the cultural orientation of the era's institutions. Nonetheless, from his beginnings, he found powerful admirers who promoted his painting, and even more his ideas. The Cardinal Francesco Maria Del Monte, Vincenzo Giustiniani, and the Mattei brothers were all part of a group that was developing the same speculations for which the Inquisition would persecute the era's other great figure, the other father of modernity, Galileo Galilei, who was also a *protégé* of Del Monte's, and was the other side of Caravaggio's coin.

Michelangelo Merisi was born on September 29, 1571 in Milan to Lucia Aratori and Fermo Merisi, architect and steward of the household of Francesco Sforza, part of a lower branch of the important Milanese dynasty, and Marquis of Caravaggio, a town a few kilometers from Milan. The Merisi family had some properties that, once sold, would support Caravaggio in his early hard years in Rome, and they also enjoyed a regular income from the Sforza marquises next to whom they lived. Far from poor, they could be called almost well-to-do in the atmosphere of great economic instability of the years between the sixteenth and seventeenth centuries for those who did not belong to the highest aristocracy.

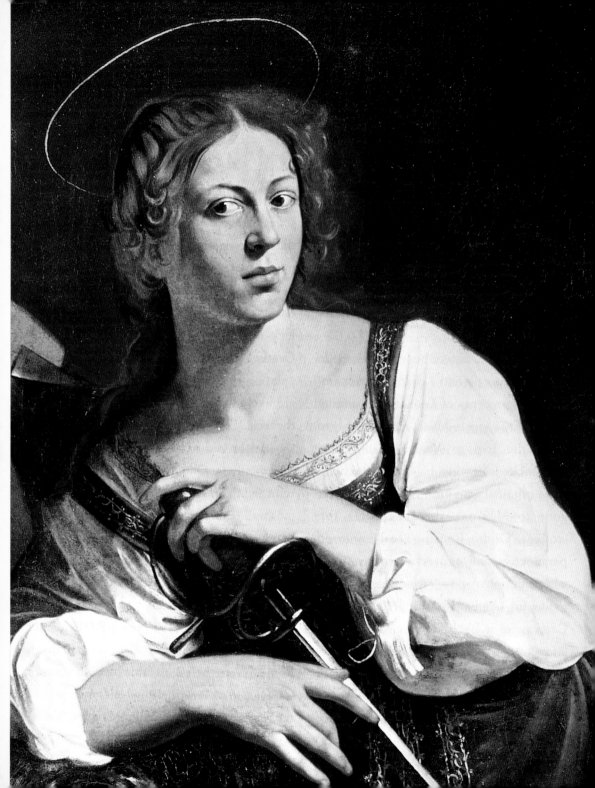

personal physician of Pope Urban VIII, states that he was involved in the first of the bloody events that would be key to the major shifts in his life and the later mythologized reputation as a "turbulent and contentious" man, reckless and violent, as he was described by Giovan Pietro Bellori, theoretician of the classicist movement, who gave rise to the legend of the *peintre maudit*.

Indeed, something must have happened in Milan to make Caravaggio leave his native land to go to Rome. Yet, we cannot know for sure if it were a criminal affair—as both Giulio Mancini and Pietro Bellori tell—or if it was the chance to prove his art in a city in full flourish.

In the summer of 1592, with his part of the inheritance, Caravaggio moved to Rome, where Clement VIII had recently become pope. The city, whose architectural and urban furnishings had just been updated by Pope Sixtus V, was experiencing a time of happy renewal from the dark period after the Sack of Rome by Charles V's soldiers, which had hobbled it in the now distant 1527. Enormous amounts of money and relative social stability made things easy for aristocratic cardinals who were young, rich and licentious, and for the new aristocracy to dedicate themselves to "that need [...] of beauty that material comforts and ornaments would satisfy" that before his death Sixtus V had deemed as necessities for the Eternal City on par with divine protection. The Church needed images to promote its Counter Reformation. Rome was overflowing with artists, stonecutters, and architects who came from all over Europe seeking work. Caravaggio was among these, but he, unlike many others, had not come unprepared.

When he arrived in Rome, he made good use of his old connections with the Sforza marquises and especially with the Colonna family, who sent him to Pandolfo Pucci, master of the household of a relative of the Colonna and an 'incumbent' of Saint

Peter's church. This accommodation was not to Caravaggio's liking, as he dubbed Pucci 'Lord Salad' for the meager fare he offered. Shortly thereafter, Caravaggio decided to go live on his own despite the poverty to which he was reduced. The only news we have of these first years in Rome, between 1592 and 1593, are those from biographers who remember Caravaggio, who was twenty-one years old, working for an obscure Sicilian painter named Lorenzo, and then his friendship with the painter Antiveduto Gramatica, for whom he must have painted the "half figures." Finally, after "an illness, finding him without money" forced him to recover at the Spedale della Consolazione for the poor, he worked at the flourishing workshop of Giuseppe Cesari, also known as Cavalier d'Arpino.

Finally, amidst this jumbled series of short and occasional artistic relationships that sources report, we have the news of Caravaggio's first painting completed in Rome, the *Boy Peeling a Fruit*, which has come down to us in many copies. The theme of the young boy portrayed against a gray background that highlights the half figure of the youth intent on peeling a fruit, dressed simply with a white shirt, involves complex symbolic references for which various meanings have been suggested. It could be an allegory of the five senses, a reference to one of the seasons, or a moralizing admonition. Whatever the real meaning of the subject addressed by Caravaggio, it remains a fact that starting with his debut works in Rome, as Mina Gregori noted, he proved himself firmly anchored in specific intellectual references such as the adoption of this theme with the half figures of young men who play instruments or perform domestic actions, painted in the northern area and directly tied to a new interest for natural imitation, which Gregori ties to the interpretation that Plinius gave to the relationship between painting and nature.

These were sophisticated cultural references and not just mere mimicking of

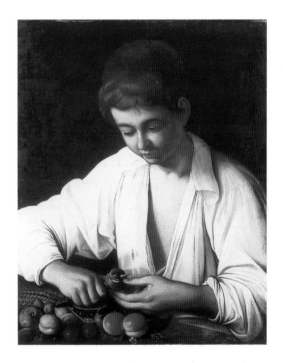

the natural world without a rational foundation, as his detractors would have it. These complex allegorical meanings also apply to the *Sick Bacchus* in the Galleria Borghese. The Bacchus's ashy flesh, in which we can recognize Caravaggio's self-portrait in these very early Roman years, makes it easy to imagine his period of illness and destitution in Rome, when he was forced to recover at the Spedale della Consolazione. Not long afterwards, when he started working in the workshop of the then rich and powerful Cavalier d'Arpino—who, incidentally, kept that *Bacchus* almost as if it were dowry, until it was seized for taxes by a papal legate in 1607—Caravaggio was able to pull himself out of his wretched condition.

Around 1593, when he became part of Giuseppe Cesari's entourage, the Cavalier d'Arpino was already the most illustrious painter in Rome, a personal friend of the new pope, Clement VIII, and "loved by princes and great personages." He was a brilliant businessman at the head of Rome's

most prosperous workshop, which produced paintings of all genres and sizes, in which Caravaggio "was employed to paint flowers and fruits," relegated to executing a single aspect of the representation. Still life was an aspect of figuration held below the painting of figures; it was an artistic genre in and of itself, which was considered inferior in the hierarchy of subjects as set by theorists of the day. Nonetheless, the genre had had a certain success in Lombardy, associated with specific symbolic meanings. Indeed, for some time a taste for this genre had started to spread among collectors, such as those paintings made in the Flemish area, where the simple reproduction of inanimate objects was performed hyperrealistically, applying painstaking attention to every detail, almost as if it were placed under a magnifying glass, to grasp the imperfections of individual elements which never failed to correspond to complex symbolic systems. This process was developed through the meticulous study of passages of light whose importance, when

possible, was made clear to the viewer by the precise portrayal of reflections of light from sources outside of the painting on bottles and other reflecting surfaces in the composition. Caravaggio knew of these techniques, and in 1672 Bellori already credited him with the spread of the fortune of this genre of painting among collectors of the era.

On the other hand, Caravaggio's main aim was still to represent the 'real' beyond any theoretical hierarchy of genres. As such, the portions of still life were equally important to those with multiple figures, with which they were perfectly integrated through the effect of a unifying light source. As we can see starting with *Boy with a Basket of Fruit*, it is true, as his contemporaries noted, "that to make a fine painting of flowers was as much work for him as to make one of figures."

The principle of 'fidelity to the real' that Caravaggio pursued was such that everyone could recognize in some of the figures represented in his paintings charac-

ters with whom he spent certain periods of his life, used as models both for compositions which were to remain in private collections, allowing a certain freedom, and for religious representations intended for another audience.

This practice would cause Caravaggio many problems over the years. Several times, he used his friends from the street, or servants like Mario Minniti or the young Francesco Boneri, as well as famous courtesans of the day such as Fillide Melandroni, and often Maddalena Antognetti; if she were portrayed in the garb of a pagan divinity, it might be acceptable, but when she appeared as the Madonna, it was summarily rejected by religious clients. The Council of Trent was clear on the point, specifying that: "all lasciviousness [be] avoided, so that images shall not be painted and adorned with a seductive charm."

Mario Minniti was a young Sicilian painter whom Caravaggio probably met in Cavalier d'Arpino's workshop and who lived with Caravaggio for about five years. The monotony of a thriving artistic factory such as Cesari's workshop where Caravaggio was relegated to a single aspect of painting, and, even more so, the need to prove himself an independent artist, led Caravaggio to try out new paths. In January of 1594, Caravaggio decided to try to 'go it on his own' and left Cavalier d'Arpino's workshop. Unfortunately, according to the third of his seventeenth-century biographers, the painter Giovanni Baglione, Caravaggio could not sell his paintings and "soon found himself in a pitiable state without money and very poorly dressed... Fortunately some charitable gentlemen of the profession came to his aid." He and his friend Mario scraped by in the netherworld of art in Rome and to make ends meet the two found themselves working for a certain "Sicilian painter who sold paintings by the dozen," which was a major step back for Caravaggio compared to his work for Cavalier d'Arpino. At least, thanks to their friend

Prospero Orsi, Mario and Caravaggio found the "comfort of a room" with Monsignor Petrignani and could continue working.

These were years of hardship for Caravaggio and it was also the period in which Clement VIII Aldobrandini, the pope elected in 1592, in a violent repressive move, had decided to clean up Rome's streets. In the days immediately following his election, the new pope banned duels and the possession of arms, took harsh measures against the carnival, card and dice playing, had vagabonds, beggars, delinquents, and gypsies expelled from the city, and prohibited gatherings of even small groups of people. Prostitution was made illegal on par with homosexuality and a strict dress code was imposed that required everyone, from prelates to courtesans, to wear an additional long-sleeved shirt over their clothes: black for priests and yellow for prostitutes. All of these measures directly affected Rome's street life of the time with its inns, its workshops, and its tennis courts in which Caravaggio passed his time and of which he would become the keenest of interpreters and chroniclers.

With his *The Fortune Teller* and with *The Cardsharps*, which he completed in these years, Caravaggio elevated the representation of this world to the level of that which at the time was recognized as the highest moral and intellectual level of painting, that was defined as being 'about history,' in other words, that which, in representing historic, noble, or religious actions, evoked examples of virtue and beauty. These were two paintings in which the life of the street was portrayed and translated with absolute fidelity to the 'real,' which opened the doors of Roman aristocracy to him, releasing him from the poverty that had led him to sell one of his paintings, which would later be among his most acclaimed works, for a mere eight scudi. It was in fact *The Fortune Teller* and *The Cardsharps* that would become his most replicated paintings, most often copied

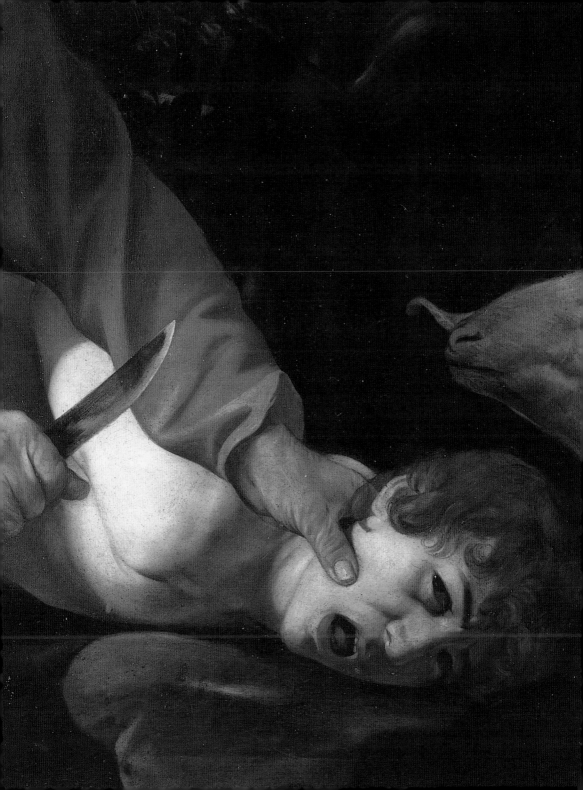

by followers and imitators in his lifetime and in centuries to come. It is hard to understand the reasons behind such lasting success for two subjects which, in theory, were in total opposition to the common sentiment of those years. Yet, the words of his contemporaries provide us the key to understanding this success, which roused keen interest even in those who were declaredly against his painting. While the moderate Giulio Mancini deemed *The Fortune Teller* the best result that could be achieved by painting from life, Giovan Pietro Bellori chose the same painting as an emblematic work of Caravaggio's style and considered *The Cardsharps* "worthy of equal praise." Meanwhile, it is Giulio Mancini's description of *The Fortune Teller* that lets us understand that, more than the subject itself (a gypsy pretending to read the palm of a knight while slipping off his ring), it was the veracity of the expression of the gypsy and the young knight that struck the imagination of the time. While the narrative context of *The Fortune Teller* could easily be placed in direct parallel to the developments of the same period in theatre, in the same painting Caravaggio had also undertaken a path whose origins went back to his studies of Leonardo started during his early years in Milan. The later development of these studies would be the authentic expressions of sorrow, wrath, and fear that define the figures of some of his subsequent works. On the other hand, with *The Fortune Teller* and *The Cardsharps*, he showed his debt to a tradition that was recognizable to the eyes of his contemporaries and universally accepted: that of the Venetan sixteenth century, and Giorgione in particular. The three–quarter view of the two paintings and the clear and bright atmosphere of these first attempts with several figures was, according to Bellori, "in Giorgione's free manner with tempered shadows."

In the years in which he painted the two works that would change his life, Caravaggio lived in abject poverty, selling off

some paintings to low-level dealers. It may have been one of these dealers, a certain 'Maestro Valentino' who sold near the church of San Luigi dei Francesi, who introduced him to the aristocratic Cardinal Del Monte, his future protector. We cannot know for sure, but it is true that Francesco Maria Borbone Del Monte lived in Palazzo Madama, near San Luigi dei Francesi. The cardinal was a powerful and accomplished diplomat, the confidante and representative of the Tuscan Grand Duke, Ferdinando I de' Medici, and well-liked by Pope Clement VIII. He passionately cultivated his artistic interests as well those in music and science. He was at the center of the era's intellectual and political life. Once he came to know Caravaggio's work, he invited the young painter to live in his household.

Caravaggio's arrival in Cardinal Del Monte's palace marked a total change in environment that influenced him and directed him towards subjects that were completely new for him. Music and musical instruments came into his repertoire. In *The Musicians*—in which the lute, the horn, the violin, and even the scores came from the cardinal's collection—Caravaggio interpreted these new iconographic objects within allegorical systems refined by classical references. This is why Caravaggio replaced the beautiful modern clothes of *The Fortune Teller* and *The Cardsharps* with soft drapes of clearly classical inspiration.

Part of these new pursuits stimulated by Del Monte's company, Caravaggio created what he himself called "the most beautiful piece that I have ever made": the *Lute Player*. The painting was commissioned by a man who may have been the richest man in Rome at the time, and would become one of Caravaggio's greatest admirers: Vincenzo Giustiniani. Giustiniani came from a Genovese family and had arrived in Rome with a relatively modest capital which in a few short years he so expanded that he could

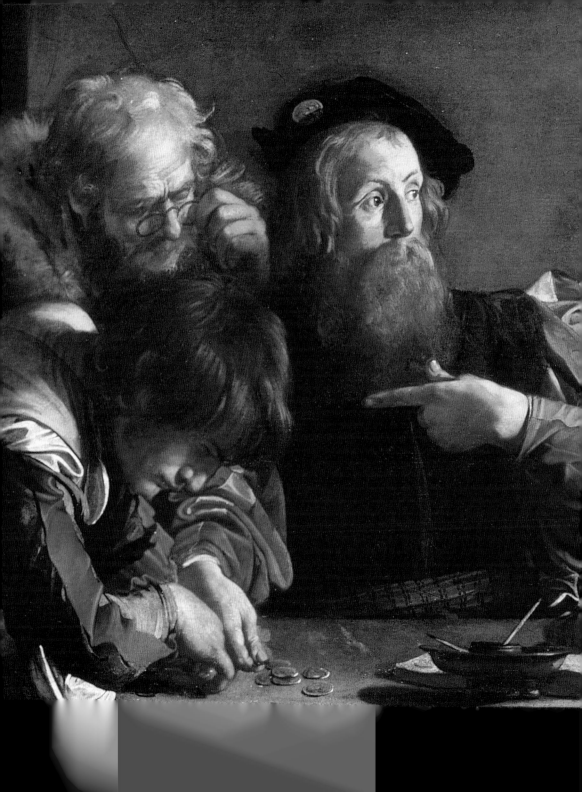

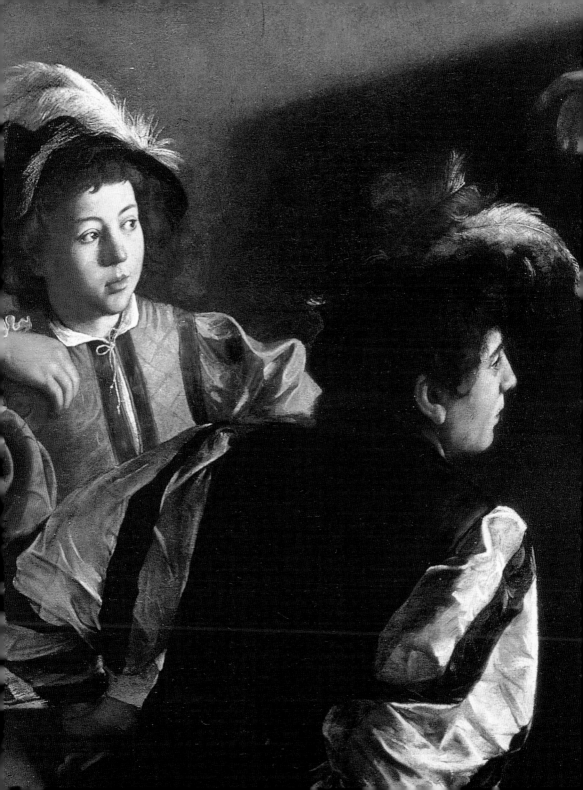

set up the first bank of the papacy. Alongside his work as a merchant and banker, he pursued musical, artistic, and scientific interests which he cultivated as more than mere aristocratic *divertissement*, approaching them as matters of speculation, evidenced by his many writings on modern painting, music, and architecture.

In those years around 1600, the relationships between music and science in Cardinal Del Monte's court were quite specific. The noble cardinal, Caravaggio's protector, took to a trend of the period, which would soon lead to the birth of opera by way of *recitar cantando*. He was an ardent supporter of musical theories that desired the return of 'simple and natural' music for soloist singers and instruments whose "only aim was to move itself in others," the antithesis of the archaic Flemish polyphonic contrapuntists.

The author of a book that expressed this passage between the old and the new was named Vincenzo Galilei; he was father of Galileo Galilei, the first modern scientist.

Galileo was a frequent guest in the palace in the period that Caravaggio lived there and it is easy to image that the two met. Cardinal Del Monte's brother, Guidobaldo, was a mathematician and physicist, as well as author of the first systematic treatise about mechanics ever written. The two Del Monte brothers supported the scientist in the beginning of his career and defended him later during the trial brought against him by the Inquisition.

In this cultural circle, interests in music, mathematics, and physics were closely linked on the basis of a new relationship with nature. In addition to the senses, this relationship had to do with optics and the science of studying nature. It may have been partly for this reason that the community embraced and promoted Caravaggio's work, fully appreciating its innovative quality.

In addition to studying music, archeology, and painting, Del Monte had botany and mineral collections; he studied geography, astronomy, and mechanics, and conducted

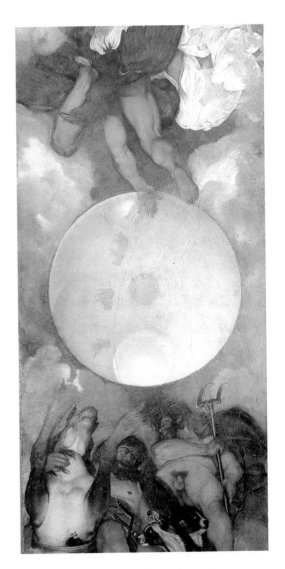

pharmacology and alchemy experiments. The cardinal decided to install an alchemy laboratory to develop his studies in the country villa that he bought in Porta Pinciana in 1596. It was on the ceiling of the laboratory, called Casino at the time, that Caravaggio made the only work of his life that he painted on a wall. It was not a fresco. Caravaggio painted the ceiling with oil, as he did canvas paintings. But he defied his detractors by portraying symbols of the alchemic trade whose origins were in Paracelsus. Jove represented sulfur and air; Neptune represented mercury and water, Pluto, salt and earth, and the characters were portrayed as if they were seen from below with a sharp foreshortening.

Representation of foreshortened views in artistic circles was universally considered a technical subject of the highest level of ability in painting. With the painting in Casino Del Monte, Caravaggio had proven himself able to handle the technique with absolute skill. In this instance, as noted by

Mina Gregori, Caravaggio referred directly to the work of Giulio Romano, known as the leading expert in this genre of painting, after he painted the ceiling of the Room of Psyche in Palazzo Te in Mantua.

As Mantua was not very far from Milan and his native city, Caravaggio could easily have known and studied Giulio Romano's work directly. This is also shown in his portrayals of expressions incited by 'movements of the soul' and the immediacy of movement in which Caravaggio found a perfect precedent for paintings that he started to paint in these years.

However, the Del Monte ceiling, abounding in virtuoso techniques developed based on universally accepted foundations, did not suffice to quiet his detractors, who rejected painting that did not have drawing as its primary foundation. One of the major accusations leveled at Caravaggio, in addition to his being uncultured, was that he "did not understand either planes or perspective" and that, as such, he had not developed

the practice of proceeding technically in composing scenes with several figures by transposing each of the models directly, and then progressively adding the individual figures, one on top of the other, starting from the one most in the background to that most in the foreground.

The manner in which Caravaggio proceeded in painting his works incited, and still incites, considerable arguments on the subject of a technique that would exclude the use of drawing by Caravaggio. The total fidelity of the representation to reality came from having each of the models pose separately and overlapping them on the canvas, creating compositions in which brief incisions were made directly on the preparation as modern reflectographic studies have shown under the oil. In all likelihood these incisions were the only reference points for placing the elements of the representation. The absence of drawings or cartoons known to have been by Caravaggio's hand would confirm the theory

of the total absence of preliminary drawing in his practice. This, as well as the fact that his paintings show no preparatory drawing under the painting, would support the theory that he never designed or planned his works through drawing. In any case, it is true that Caravaggio resolutely refused to give drawing the importance that it was officially given in his time, inciting much scandal among his contemporaries.

Between 1595 and 1596, in the wider context of representing nature, Caravaggio's studies pursued the transposition of what in the era were known as 'movements of the soul,' i.e. the changes in expression caused by extreme feelings of joy, anger, sorrow, or fear. The painting of the *Boy Bitten by a Lizard* that we know in two versions, which, as is true for others of Caravaggio's works of which we know several replicas, shows a self-portrait at the instant of the sudden movement caused by an animal bite. The face appears frozen in a mixture of pain and anger that we cannot but put in relationship with the sketches of faces captured in moments of surprise, sorrow, or laughter that Leonardo made as part of his studies of realistic portrayals of the natural world and 'movements of the soul.'

Caravaggio could well have known Leonardo's studies from his Milan years as there are studies on comparable subjects made by painters from that area. However, it is also true that Guidobaldo Del Monte owned one of the rare manuscripts of Leonardo's *Libro di Pittura* which would only be published after Caravaggio's death, but which he nonetheless could easily have consulted. Furthermore, in Lombardy, Leonardo's lesson was still alive and well after just under seventy years since his death.

The severed head of Medusa is at the origins of these experiments of representing extreme expressions which would play a major role throughout Caravaggio's career. It is vividly real, caught in the scream of horror amplified by the wild movement of

the serpents and the gushing blood. Caravaggio depicted this Medusa on a shield that Del Monte commissioned him as an homage for the Grand Duke Ferdinando I de' Medici.

Yet, was it mere chance that several decades before Caravaggio completed *Medusa*, which is still in Florence, a visitor to the sumptuous Medici collection, and later Giorgio Vasari, lingered on the description of the same subject by Leonardo (since lost) apparently part of the same collection?

Leonardo's studies were a terrain in which Caravaggio often delved. Yet that askew gaze with the pupils bulging and the mouth fixed in a scream must have also referenced the extreme expressions of classical masks, tying into a classical tradition both in the theme of the depiction, the Medusa of ancient Greek mythology, and in its treatment.

The same immediacy of action would be captured by Caravaggio in *Judith Beheading Holofernes* painted around 1599, in which he chose to portray the very moment in which Judith kills the tyrant Holofernes, ignoring all of his illustrious predecessors. Here, Caravaggio connects the action of beheading to the tyrant's expression of horror and the frowning Judith's physical exertion, proving once again his ability to sidestep usual painting procedures, the result of tests, studies, plans based on famous examples, to depict his models directly in action.

Giovan Pietro Bellori liked to say how Caravaggio took his models from the street. However, it is more likely that he used people that he knew from before he moved to Palazzo Madama at Del Monte's and whom he had continued to frequent. Otherwise, as with the model for Judith, they were people suggested by his protectors. That was so in the case of Fillide Melandroni. Caravaggio used Fillide several times as a model for his paintings both in the role of a heroine and a saint. Around 1599 she was at the peak of her career as a

prostitute. It makes little difference whether Caravaggio had met her hanging around brothels, inns, squares, and tennis courts, or whether he was first asked to paint her portrait as a protégée of the Marquis Giustiniani, with whom she was arrested in 1601. The fact remains that her frowning expression and her murdering gesture were the opening of Caravaggio's full realization of his studies on light, movement and the movements of the soul, first undertaken years before. This opening would soon after help him fully resolve the problems of decorating the Contarelli chapel in San Luigi dei Francesi.

In 1599, Caravaggio received a commission to decorate the chapel, which presented a complex collection of problems. Mathieu Cointrel, the Frenchman who became Cardinal Contarelli and had bought the chapel in the church of San Luigi dei Francesi in 1565, had died some time earlier. His will executor, Virgilio Crescenzi,

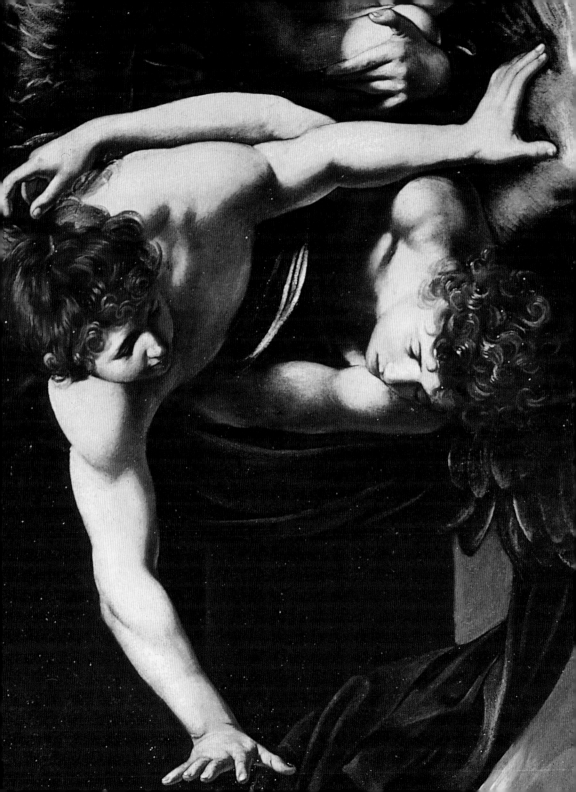

had assigned this painting decoration to Cavalier d'Arpino in 1591. D'Arpino painted the frescoes of the ceiling, but then, overburdened by more prestigious papal commissions, left the chapel without that part of the decoration that the cardinal had specifically requested before dying. The altarpiece and the decoration of the side walls were still lacking. After repeated complaints from the congregation of San Luigi dei Francesi who did not want to find themselves in the holy year 1600 with one of the chapels still incomplete, in accord with Crescenzi, Cardinal Del Monte arranged for Caravaggio to receive the commission. The urgency of the congregation and Caravaggio's desire to win the commission are evident in the fact that Caravaggio committed in writing to complete the work by the end of 1599, and in painting the works promised to hold to instructions provided earlier to his former master, Cavalier d'Arpino. For the work, he would receive the amount of azure and ultramarine blue paints that Crescenzi's painter, Placido Roncalli, had estimated necessary. He would also have an immediate advance of fifty scudi. Nothing that he had done to this point had come close to presenting the difficulty of the task before him. Nonetheless, only six months behind the set deadline, he completed the work.

The portrayal of *The Calling of Saint Matthew* and the *Martyrdom* of the saint, requested in extreme detail by the Cardinal Contarelli, were painted on two enormous canvases. Such a large support on the walls of a chapel in place of a fresco was already in and of itself completely new in Roman churches, not to mention the interpretation that Caravaggio gave to the two subjects. *The Calling of Saint Matthew* was a depiction of a scene of everyday life whose size saved it from any rhetoric coming from the stream of bright light that goes with the direction of Christ's gesture connecting it to that of Matthew's in a temporal dimension locked in this single movement. After repeated

49

compositional *pentimenti*, all recorded below the painted surface, *The Martyrdom of Saint Matthew* developed concentrically around the figure of the executioner in the act of striking the future martyr. Everything did not go smoothly; the first version of the altarpiece with *Saint Matthew and the Angel* was later painted for the side walls in 1602. Once it was placed on the altar of the chapel the congregation considered it too 'strong' and could not accept seeing the feet in the foreground, perfectly foreshortened and projected towards the churchgoer, with this saint who seemed an illiterate getting help in reading from the angel. Caravaggio replaced the painting with a new version that was more fitting to the tastes of the confreres.

By this time Caravaggio had achieved fame, and his public approval was established. He had reached the fullness of his language in monumental and dramatic terms. It was light that held everything together in the Contarelli paintings, a symbolically divine light whose conception returned to Leonardo's ideas of representation and perception of reality through the interpretation that the Lombard theorist and painter Gian Paolo Lomazzo had assigned them in his *Idea della Pittura*. The dialectic between light and shadow that led Caravaggio to "strengthen the darks" had been definitively developed to become formally indispensable for the purpose of depicting nature as he had so long sought to do.

The report written by the Dutch painter and critic Carel van Mander in his *Life of Painters* in 1603 also brought the news that "there is also a certain Michelangelo da Caravaggio who is doing extraordinary things in Rome" and, quite prophetically, that his "style is one for our young artists to follow."

Caravaggio's fame had grown to such an extent that in a later contract for a second chapel, signed in September of 1600, he was offered a payment of four hundred scudi. The client, Tiberio Cerasi, was a friend of

Vincenzo Giustiniani, and so wealthy that he could buy himself the position of treasurer of the Apostolic Chamber and Pope Clement VIII. Cerasi had recently purchased a chapel in the church of Santa Maria del Popolo in Rome where he wanted two works depicting the *Conversion of Saint Paul* and the *Martyrdom of Saint Peter* for the chapel's side walls and an *Assumption of the Virgin* for its altarpiece.

Tiberio Cerasi divided the commission to decorate the chapel. In addition to commissioning Caravaggio for the side wall paintings, he also brought in the other early seventeenth-century painting star of Rome, Annibale Carracci, a painter who would be known as the antithesis to Caravaggio's faithful-to-the-real painting. Carracci had imported from Bologna the revival of the late manner founded on a new interpretation of Raphael and Michelangelo's lesson, seen in the light of a return to the sensuality of nature and classical sculpture as fundamental models. The juxtaposition of works by two such different artists served to showcase the period's foremost art in a single location. Nonetheless, problems reared their heads once again.

Annibale Carracci's *Assumption* was immediately accepted, but Caravaggio's first version of *The Conversion of Saint Paul* was rejected. Perhaps the client saw too much emotion in the scene; at any rate, Caravaggio redid the same theme in a version governed by the absolute still of the two human figures, the horse, and the divine light. The same atmosphere of suspended immobility was used for *The Martyrdom of Saint Peter*, whose final version was likewise a second version.

This was not to be the last of Caravaggio's letdowns. *The Death of the Virgin*, which now hangs in the Louvre, was painted a few years after the Cerasi paintings for the Cherubini chapel in Santa Maria della Scala, and would also be rejected.

For the faithful it was unthinkable to be faced with a scene of grief so close to the contemporary age, with a Virgin so like the

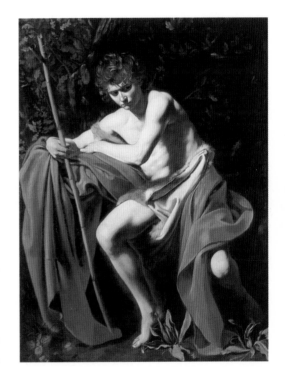

women of Rome in the early seventeenth century; a Madonna completely lacking in divine attributes, save the thin golden halo behind her head, could not be accepted. Yet was this the reason for its rejection? Or was it, as Caravaggio's biographers reported, that the friars had the painting removed because Caravaggio had "portrayed as Our Lady a courtesan he loved" or because he "portrayed the Madonna with little decorum, swollen, and with bare legs "?

In every instance, Caravaggio quickly presented new versions and the first versions of the rejected paintings were always immediately bought by someone else; this was the case for *The Death of the Virgin*, which Pieter Paul Rubens hastened to bring to the Duke of Mantua in 1607. The first version of *Saint Mathew and the Angel* (destroyed during World War II) was also quickly bought. Vincenzo Giustiniani snatched it up, which was probably easy, as he was (as was often the case) listed in Caravaggio's contract as the mediator for financial issues. The work was

included with another fourteen works by Caravaggio recorded in the inventory (from about 1630) of his vast collection. The inventory's executor Joachim von Sandrart, mentioned that one of the fifteen Caravaggio works was considered truly special: "This piece was shown publicly in a room together with another 120 paintings by the most outstanding artists; but at my suggestion it was given a dark green silk covering and only when all the others had been seen properly was it finally exhibited because it made all the other rarities seem insignificant."

The painting was *Cupid,* which now hangs in Berlin and which Caravaggio completed between 1602 and 1603. Posing for it was Cecco Boneri, his young servant who would later become a painter in his own right. Giustiniani had purchased the work for two hundred scudi or less; it was later assessed at ten or fifteen times that amount and considered an undisputed masterpiece, to the extent that many avant-garde poets dedicated madrigals and epigrams to it. Despite his

rejections and run-ins with the law, the artist had been definitively crowned as a master.

In June of 1601, while he was beginning the second version of a painting for Tiberio Cerasi, Caravaggio signed a contract for a new job in which the artist is listed as "resident in the palace of [...] Cardinal Mattei." It is unclear whether he actually changed residence. We do know that from the spring of 1601 to 1603 the artist completed many works for Ciriaco Mattei, including the *Supper at Emmaus* in London, the *Saint John the Baptist* in the Pinacoteca Capitolina in Rome and the version of *The Betrayal of Christ,* recently identified as the one in Dublin, for which he was paid one hundred and twenty-five scudi.

Meanwhile, he continued to paint for another of his faithful protectors, Vincenzo Giustiniani, without giving up any public commissions. In fact, it is likely that in 1602 Caravaggio started to work on the only public work that found favor even among his detractors, the *Deposition* in the Pinacoteca

54

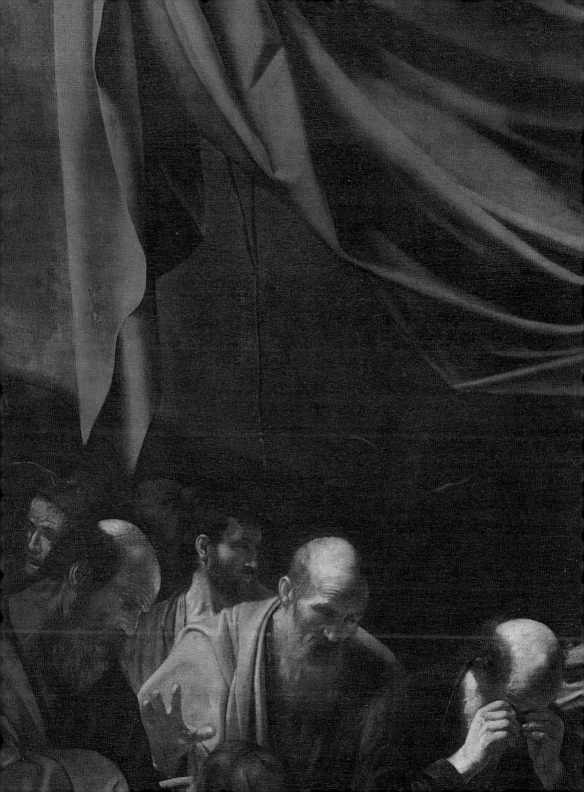

Vaticana. Gerolamo Vittrici commissioned the painting to Caravaggio, possibly to fulfill the will of his uncle Piero, who died in 1600 and had been the majordomo to the pope. The altar was to decorate the family chapel in the new church in Rome, Santa Maria in Vallicella, and it is in fact here that it was recorded in September of 1604. It may also have been to avoid another rejection that, without compromising his fidelity to the 'real,' Caravaggio rendered the event in a monumental style, letting references to "high models" come through, such as classical sculpture and Raphael's painting.

The only document that we have which faithfully reports some thoughts on painting that Caravaggio authored himself is dated September 13, 1603. He and some of his friends were accused by the painter Giovanni Baglione and Tommaso Salini of having written some slanderous sonnets about Baglione circulating at the time.

Thanks to his powerful supporters, Caravaggio got out of hot water, but his deposition would be of essential importance for understanding the achievement of his painting pursuits. In a time of complex philosophical debates about the licentiousness of some images, about the hierarchies of genre in painting and the role of drawing, mainly conducted within the Academies, Caravaggio stated that "in painting a *valent'huomo* is he who knows how to paint well and to imitate natural objects well."

However, for his contemporaries the problem would not have been just some of his works being in churches or within a well defined circle of collectors. Rather, it was the fact that, as Bellori put it, "The painters then in Rome were much taken by the novelty of this approach, and the young ones particularly gathered around him and praised him as the unique imitator of nature. Looking upon his works as miracles, they outdid each other in copying him." Caravaggio was subverting the system, and, almost against his will, creating a growing number of imitators and followers.

In the span of three years, between the Baglione slander trial in 1604 and the resolution of the attack on Mariano Pasqualone, a notary of the ecclesiastic state, Caravaggio was arrested and put in prison five times. In each case, however, he continued to work, for both private clients and on public works such as that for the chapel in the church of Sant'Agostino in Rome owned by the Cavalletti family, the *Madonna of Loreto* or *dei Pellegrini*, and his *Madonna dei Palafrenieri*, which was intended to adorn a chapel in Saint Peter's, but, as had already happened in other instances, was removed and replaced. Caravaggio completed this work after the problems resulting from the attack on Pasqualone were resolved. It was these problems that caused the first of a long series of sudden flights that defined the last years of his life. Fleeing to avoid the indictments and investigations underway as a result of the Pasqualone matter, Caravaggio had reestablished the connections of his youth in his birth city. Costanza Sforza Colonna, the Marquise of Caravaggio, whom he knew from when his father was still alive, had since been widowed and frequently stayed in Rome, where her brothers lived, one of whom was the powerful Cardinal Ascanio Colonna. It was almost certainly Ascanio and Costanza Colonna who sent Caravaggio in 1605 to Genoa to their niece's husband, the most prominent man in the entire Republic, Prince Doria.

According to a reference in a letter from the ambassador of the Duke of Modena, Prince Doria was so enthusiastic about Caravaggio's painting that he offered him six thousand scudi to fresco the loggia of one of his homes. Marcantonio Doria had formed a personal relationship with the artist and his exceptional offer was aimed at keeping Caravaggio in Genoa. However, Caravaggio refused it and returned in August of 1606 to Rome, where he found himself in serious trouble. The few possessions that he owned had been seized because, according to the landlady of the house he had rented in Vico

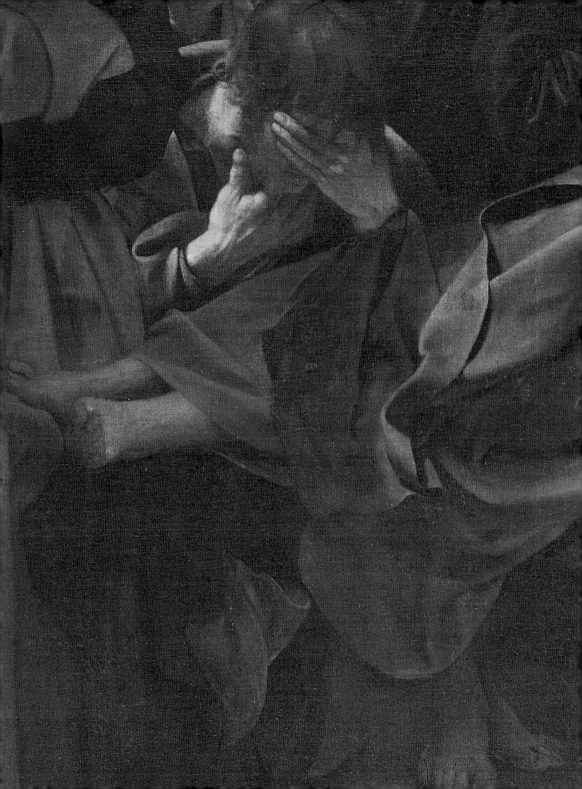

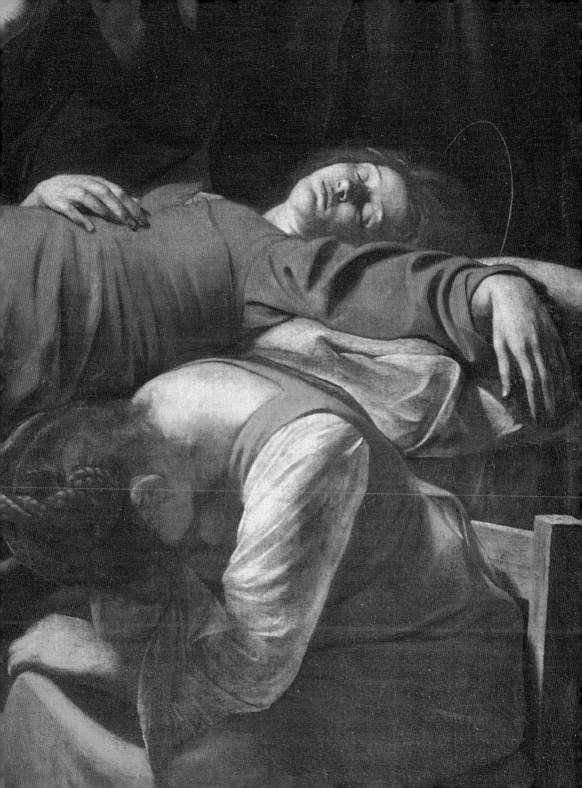

San Biagio in Rome, he had not paid rent for six months and all of the money that he had earned in the past had by now certainly dried up. Otherwise it is hard to imagine why, in October of 1606, Caravaggio would have accepted a payment of only seventy-five scudi for an altarpiece for Saint Peter's, Rome's most important church. While it is true that painting a work in such an important place would have heightened his honor and fame, the fact that he agreed to such a low price, when a normal compensation would have been around at least two hundred scudi, supports documented clues from the time that show the artist in desperate search of money.

During the completion of Saint Peter's construction, which had been under way for a century at that point, the chapel of the papal Palafrenieri had been moved and needed a new altarpiece. Caravaggio was chosen; they wanted the altarpiece to portray the figure of Anne, the patron saint of the Palafrenieri and mother of Mary. In accordance with client instructions, Caravaggio portrayed

Mary and the Child in the act of crushing the serpent of original sin in Anne's presence. Caravaggio gave the scene the domestic nature that is seen in some Lombard altarpieces of the previous century. But, yet again, his work was removed and sold by the clients to Scipione Borghese. On par with Vincenzo Giustiniani, the Mattei family, and Del Monte, Scipione had long been one of Caravaggio's greatest admirers. Caravaggio also painted *Saint Jerome* for him, which now hangs in the Galleria Borghese.

Scipione Borghese was cardinal and nephew of the new Pope Paul V, elected to the papal throne in May of 1605. It was exactly one year after his election, during celebrations for the anniversary of his coronation that "a serious quarrel took place in Campo Marzio with four men on either side, the leader of one being Ranuccio da Terni, who died immediately after a long fight, and of the other Michelangelo da Caravaggio, a painter of some renown in our day who was reportedly wounded but whom

it is impossible to locate." Ranuccio da Terni was a Tomassoni, an influential military family in the pro-Spain party, which had recently become aligned with the new pope's politics. Apparently, Ranuccio da Terni did not have a respectable profession and he frequented palaces of cardinals—most likely as a pimp—and he had recently taken to moving around armed along with his *bravi*. When Caravaggio "injured and killed" Ranuccio, the accomplices of the one and some friends of the other were involved in a violent brawl and, according to accounts, were those who started the initial dispute. While we do not know with certainty what the original motivation was and who started the fight, recent studies have advanced a plausible theory that Caravaggio was indebted to Tomassoni since the time of his return from Genoa.

As at the time of the brawl in Campo Marzio it is likely that the painter had not yet honored his debt, Tomassoni would have had an extra motive for attacking Caravaggio, who in defending himself might have injured him and caused his death.

Once again Caravaggio had to flee Rome to avoid ending up in the hands of justice. He again went to the Colonna family, who had properties southeast of Rome, in Zagarolo, Palestrina, and Paliano where Caravaggio spent four months moving from one estate to the other, awaiting his sentence. When his death sentence was issued, Caravaggio had to leave the papal kingdom indefinitely and move to Naples, in the palace of the Prince of Zagarolo, Don Marzio Colonna.

At the time, Naples was the capital of the Kingdom of the Two Sicilies, the second–largest metropolis in Europe after Paris, and three times larger than Rome. Don Marzio Colonna's influence brought Caravaggio commissions that kept him busy throughout the winter of 1606 and early 1607. Out of these works, that for Pio Monte della Misericordia was doubtlessly his

*The Beheading of Saint John
the Baptist* (detail), 1608
La Valletta (Malta),
oratory of Saint John the Baptist
of the order of knights

most prestigious public work. This congregation consisted of some young aristocrats from the city who wanted to portray the seven works of mercy on a large altarpiece, the six works enunciated by Christ in the Gospel of Matthew and the burial of the dead, which after the recent plague, had become a critical problem for Naples. In a very short time, Caravaggio portrayed the seven works, presenting a complex and animated theatrical machinery inspired by street life. *The Seven Works of Mercy* would revolutionize the entire world of southern painting, becoming a primary reference point for all artists who went to train there.

Other commissions followed *The Seven Works of Mercy*, including the *Madonna of the Rosary* for the Carafa Colonna family and the *Crucifixion of Saint Andrew* for the viceroy of Naples. Despite his success in Naples, Caravaggio was still condemned in absentia and as such could not return to Rome, the city to which he owed his fame and prestige. Nonetheless, to escape his death sentence, he took another opportunity offered him by the Colonna family. The marquise Costanza's second son, Fabrizio Colonna, was about Caravaggio's age, and likewise had been convicted of serious crimes. In 1606, Fabrizio had nonetheless been named commander of a fleet of the order of the Knights of Malta. About seventy-five years earlier, Malta had become the headquarters of the order of Knights of Saint John of Jerusalem, a religious order that took in the most unruly noble youth, offering them a kind of immunity. As such, it is believable that Caravaggio, still under the protection of the Colonna family, found his only path of salvation in the chance to enter this order.

After a short visit to Malta in 1607, Caravaggio returned in the spring of the next year and began the portrait of the Grand Master of the Jerusalemite order, Alof de Wignacourt, which now hangs in the Louvre. This seems to have been an advantage for Caravaggio in all ways, instantly giving him all of the privileges that the young aspiring

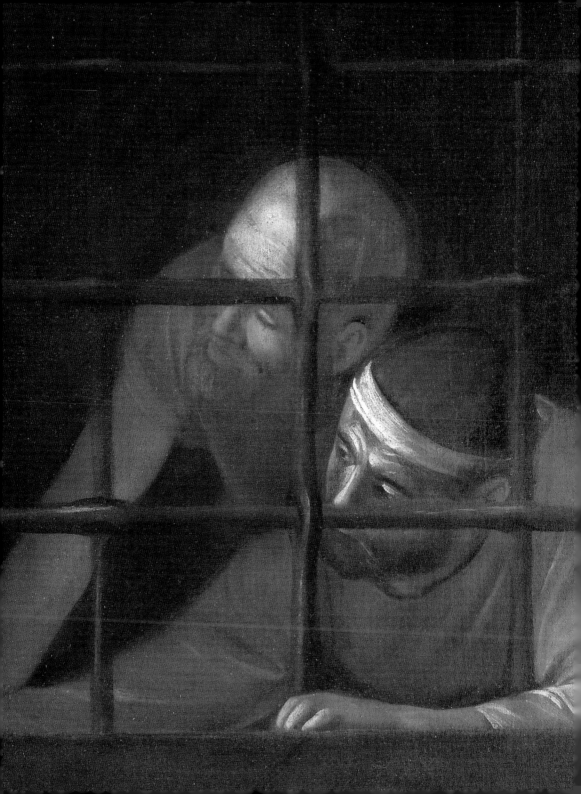

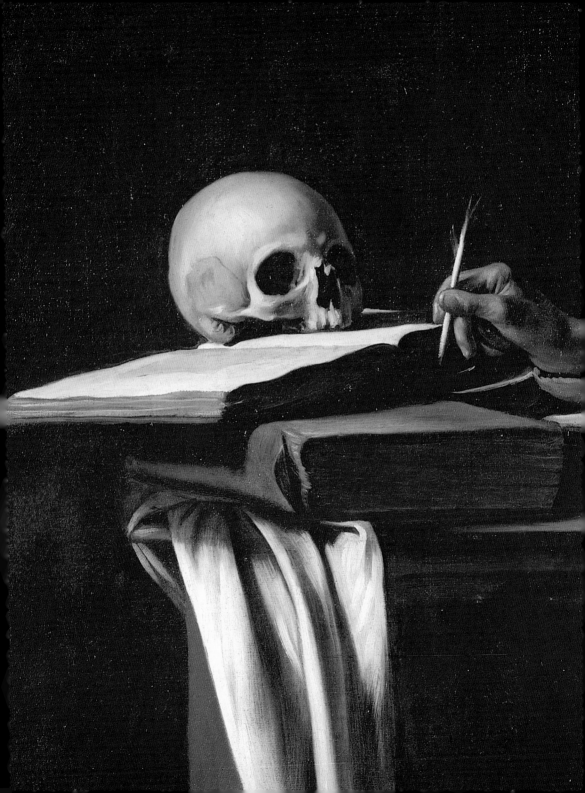

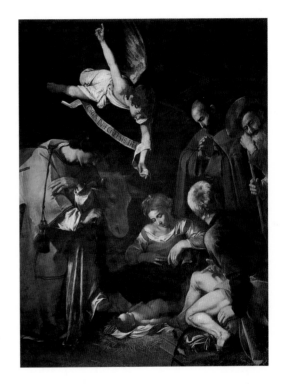

Nativity, 1609
Formerly in Palermo, oratory of
the Compagnia di San Lorenzo

Carlo Saraceni, and Orazio Gentileschi.

In Naples and in the south, his fame was more enduring and his influence came to the brink of the eighteenth century in the work of Luca Giordano. However, in the rest of Italy, within a few decades after his death, his fame was crushed under the weight of the Baroque movement, and then the even heavier weight (because carefully planned) of the classicist movement championed by Giovan Pietro Bellori. The paintings and language of Michelangelo Merisi had fallen into oblivion, where they would stay until the critical rediscovery of the role of the painter in the mid–twentieth century launched by Roberto Longhi's studies.

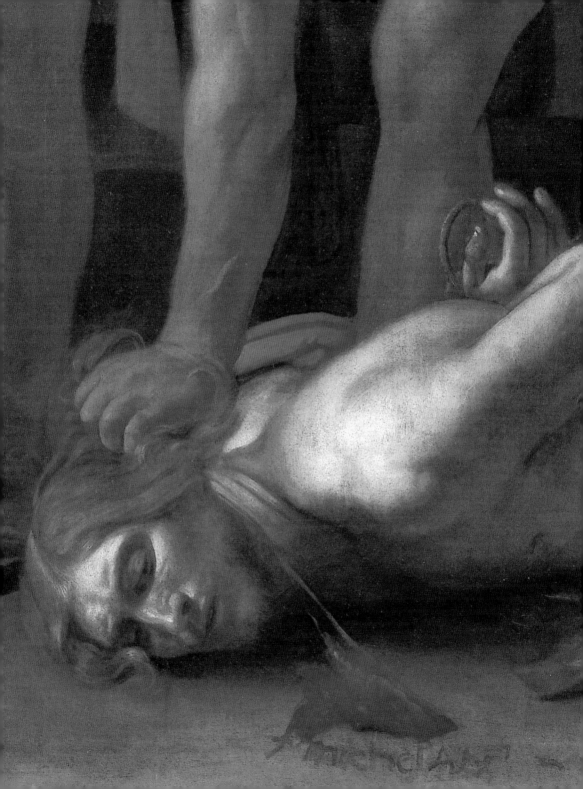

The Masterpieces

Boy with a Basket of Fruit

1593–1594
Oil on canvas, 70 × 67 cm
Rome, Galleria Borghese

In 1607, Pope Paul V Borghese's tax officer took from Cavalier d'Arpino's workshop "a painting of a youth holding a basket of fruit in his hands" from Caravaggio's early Roman years. That "youth holding a basket of fruit" describes this painting that can be easily tied to the period in which Caravaggio, recently arrived in Rome, painted "flowers and fruit" for Giuseppe Cesari, known as Cavalier d'Arpino. These were the years 1593–1594, the dates attributed to this painting, which bears all of the Lombard background of Caravaggio's youth.

The care with which the details are described; the yellow leaf that is about to fall, the gash of the ripe fig and the pockmarked stem leaves all fit with this early Lombard training where Leonardo's scientific naturalism incited early experiments in representing elements belonging to the still life genre, which in the Padana area contributed to emphasizing the domestic tone of many depictions.

We can attribute to this same background the naturalistic value of the stream of light that cuts through the background, precise reflections, such as that on the boy's neck and the subtle passages of white on his shirt. Light contributes to creating the space within which the figure moves, highlighting the pose's mobility, the slightly parted lips, the neck tilted back and the transience of the instant capturing the boy and the abundant basket that he holds.

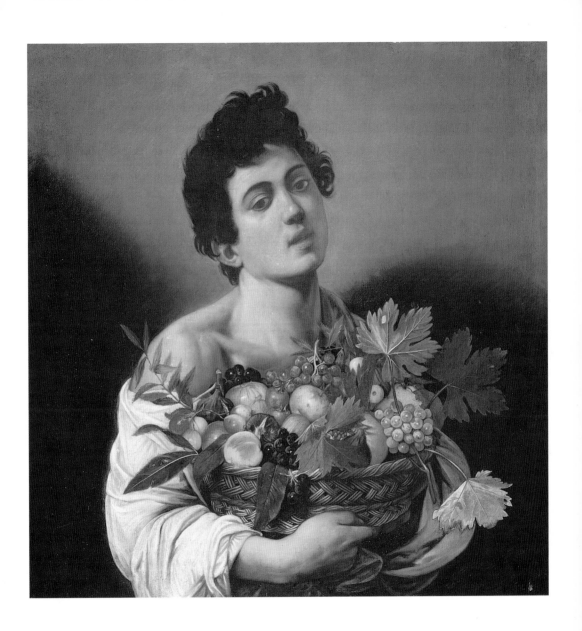

Self-portrait as Sick Bacchus

1593–1594
Oil on canvas, 67 × 53 cm
Rome, Galleria Borghese

The *Sick Bacchus* was with *Boy with a Basket of Fruit* among the paintings seized from Cavalier d'Arpino in 1607. It can be counted among the first works by Caravaggio painted in Rome, around 1593. The nickname given to the painting, *Sick Bacchus*, describes the unusual portrayal of the god. Caravaggio's self–portrait as Bacchus is connected to the Milanese environment, specifically to the work of his first master, Simone Peterzano, in the classical clothes in which he is dressed and the exaggerated pose.

The compositional angle of the work clearly focuses on the twist of the head towards the viewer, rendering Bacchus's gaze all the more intense. His scant smile draws from the realistic vein of those half figures that from Lombardy would be more widely developed in Emilia with the Carracci. Its realistic accents and its study of light values also account for considerations such as the bluish tint to the lips and eye sockets, as well as the pale reflections of the figure's flesh. The figure is identified as a self-portrait of Caravaggio and dated in relationship to a period of illness in which he was in such a state of poverty that he had to recover at a hospital for the poor, according to one of his historic biographers.

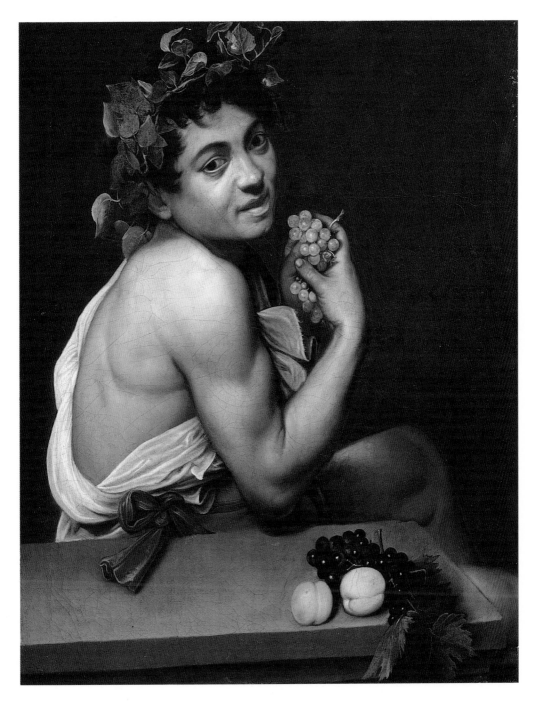

The Fortune Teller

1593–1594
Oil on canvas, 115 × 150 cm
Rome, Pinacoteca Capitolina

This painting is dated by modern art historians around 1593–1594 and was commissioned by the Monsignor Petrignani with whom Caravaggio had found "the comfort of a room" in 1595. A few years after its completion, Giulio Mancini, one of Caravaggio's biographers, maintained that, "Of this school I do not think that I have seen a more graceful and expressive figure than the Gypsy who foretells good fortune to a young man by Caravaggio." With these words, Mancini noted the painting's enormous critical popularity, which together with *The Cardsharps* is one of the paintings most copied and reinterpreted in the seventeenth century and thereafter.

The two paintings are the first affirmation of the revolutionary language that Caravaggio professed in Rome in the years after working with Cavalier d'Arpino. The painting was purchased by Francesco Maria Del Monte, who took Caravaggio into his household and became one of his most stalwart protectors. The cardinal liked the subject taken from contemporary street life and also understood the sophisticated transposition of gazes and expressions between the young gypsy woman who is reading the hand of the knight, intent on listening to her words, while she slips off his ring.

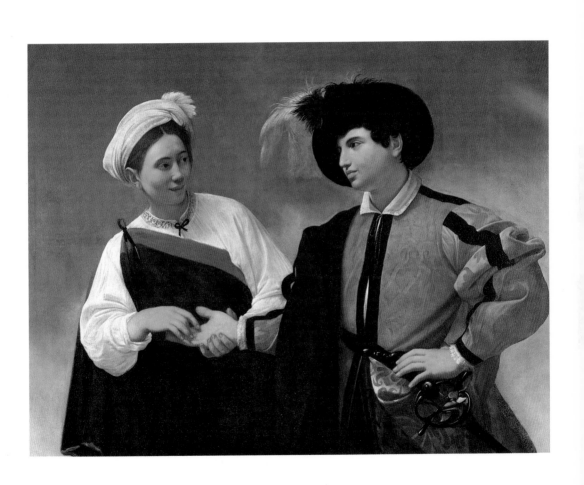

The Cardsharps

1594
Oil on canvas, 94.2 × 130.9 cm
Fort Worth, Kimbell Art
Museum

As Giovan Pietro Bellori reported in 1672, this picture "was bought by Cardinal Del Monte who being a lover of painting helped Michele out of his difficulties by giving him an honored place in his house among his gentlemen." The piece was painted around 1594, after he left Cavalier d'Arpino's studio. It opened the doors of Roman aristocracy to Caravaggio and enjoyed so much success that it was copied over fifty times. Its composition is part of Caravaggio's first attempts at painting several figures.

The three characters compose a three-dimensional effect in which the box of dice, the cards and the table contribute to the spatiality created by the expressions and gestures that connect them. The three players are set in a clear and bright atmosphere. The variety of the floral vest of the cardsharp who is peeking at the cards of the player beyond the table serves as a counterpoint to the brilliance of the gold yellow of the vest of his accomplice. This demonstrates perfect color modulation in relationship to passages of light, whose origin goes back to Caravaggio's early Lombard training, which introduced him to luminous Venetian delicacy.

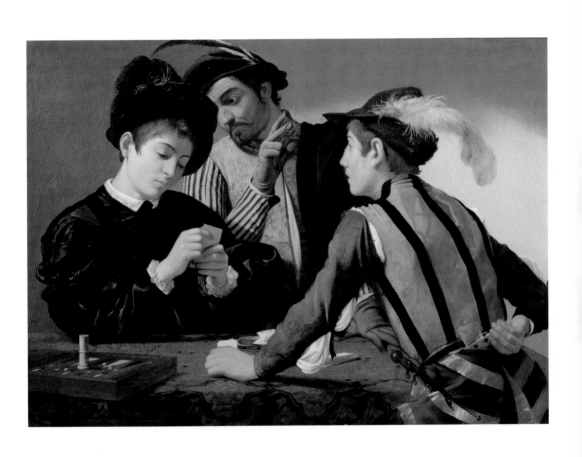

Saint Francis in Ecstasy

1594–1595
Oil on canvas, 92.5 × 128.4 cm
Wadsworth Atheneum,
Hartford, Connecticut,
The Ella Gallup
Sumner and Mary Caitlin
Sumner Collection Fund

Saint Francis in Ecstasy is Caravaggio's first surviving religious painting. The painting was in Cardinal Francesco Maria Del Monte's collection and probably dates to the beginning of Caravaggio's stay in the cardinal's palace in the years between 1594 and 1595. It is a depiction of Saint Bonaventura's text about Saint Francis on the Mount of Verna accompanied by his companion Friar Leone and some shepherds around a fire, seen nearby in the background to the left. The position of the saint in a faint, sprawled in the angel's arms, and the absence of the stigmata show Caravaggio's desire to highlight the event's spiritual aspect. The interiorized interpretative key of the ecstasy is reinforced by the nighttime setting of the scene, in which the saint and angel are illuminated in the foreground by a soft light that caresses the earthy tones of the colors and renders the white clothes of the angel all the more brilliant. The careful depiction of the vegetation in which the saint has collapsed is similar to Caravaggio's still life from the same period, making it likely that there is an intentional and possibly symbolic choice of the plants depicted. In the golden streaks of sky in the background we can recognize Caravaggio's Lombardy and Veneto influences, though he had by this point fully developed his own language, with consideration as well for of the classical culture found in Rome, of which this painting offers evidence in the transparent handling of the almost Alexandrian-style clothes that cover the angel.

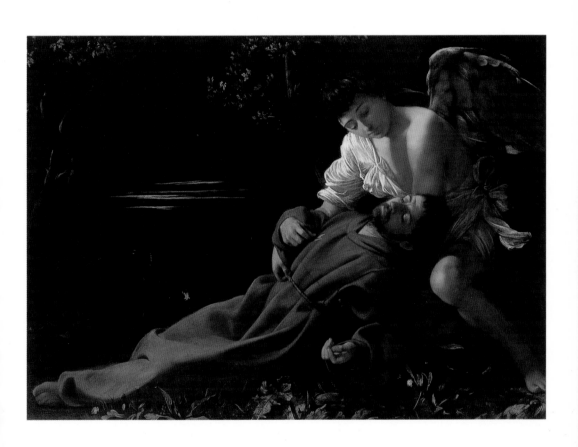

Penitent Magdalen

1594–1595
Oil on canvas, 122.5 × 98.5 cm
Rome, Galleria Doria
Pamphilij

As Giovan Pietro Bellori reported in 1672, Caravaggio "painted a young girl seated on a chair with her hands in her lap in the act of drying her hair; be portrayed her in a room and, adding a small ointment jar with jewelry and gems on the floor, he pretended that she was the Magdalen." Caravaggio 'pretended' that one of the women he knew, and whom he would often use as a model for his paintings, was Magdalen, placing her in the center of an empty space whose depth is made perceptible by the pattern of the bricks in the foreground that gradually fade into total darkness, where the device of the stream of light has a double value, symbolic and functional, adding depth to the space while evoking the divine presence. Caravaggio interpreted the religious theme with a domestic approach based on his Lombard training on the example of Savoldo, Moretto, and Romanino. The few attributes of Magdalen, the broken necklace and the vase with water, are not elements inserted artificially; they are necessarily part of the whole of that, fidelity to the real that Caravaggio pursued since his first steps out of Cavalier d'Arpino's workshop.

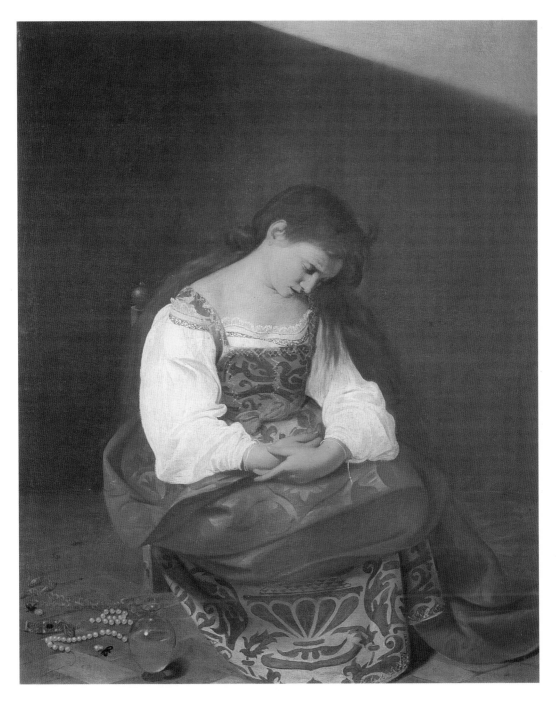

The Musicians

1595
Oil on canvas, 87.9 × 115.9 cm
New York, The Metropolitan
Museum of Art, Roger Fund

According to Giovanni Baglione, a few years after Caravaggio's death, once he was welcomed in Palazzo Madama by Francesco Maria Del Monte, he "painted for the Cardinal youths playing music very well drawn from nature." The painting is one of the most representative examples of the cultural atmosphere of the cardinals' court, where music and art were objects of discussion and study on par with science. Before being made cardinal, Del Monte had written to a friend: "You know that I play guitar and sing Spanish song." His passion for music led him to form an extensive collection including the instruments and sheet music that Caravaggio depicts here.

The painting portrays a complex pagan allegory, which the client surely dictated to Caravaggio, in which the presence of winged Cupid who is picking the grape bunch has inspired erotic interpretations. In keeping with the theme, Caravaggio moved from realistic depictions in modern clothing of his first paintings of his Roman period to the classical evocations with the soft, white clothes that the young men wear and the presence of the pagan divinity. The naturalness of the poses are matched by the young men's enchanted expressions with partially open mouths and the shiny gazes directed outside of the painting breaking the intimacy of the representation and going back to that 'fidelity to the real' that Caravaggio strenuously professed.

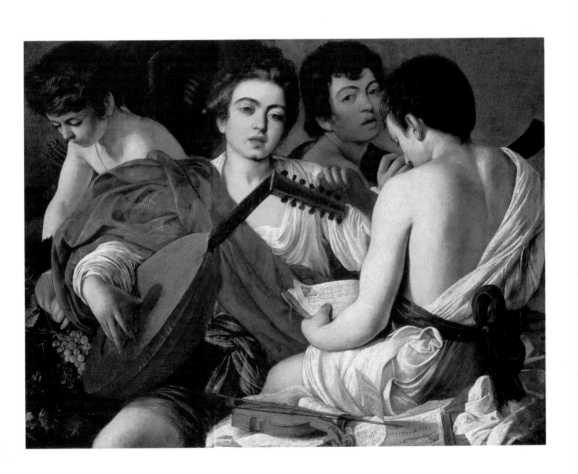

The Lute Player

1595–1596
Oil on canvas, 94 × 119 cm
St. Petersburg, The State
Hermitage Museum

Giovanni Baglione praised this painting in 1642, saying he painted "a youth playing a lute. Everything in this picture looked alive and real, most notably a carafe of flowers filled with water in which one could easily distinguish the reflections of a window." This was likely one of the first paintings to become part of the large collection of Caravaggio's paintings owned by Vincenzo Giustiniani, who probably commissioned the work.

The painting's theme dates back to the period in which Caravaggio lived with Cardinal Francesco Maria Del Monte, a fine musician and dedicated scholar of new theories in music, who owned a vast collection of musical instruments and sheet music, well represented by Caravaggio in his music-themed paintings. While the perfect foreshortening of the instruments left on the table and the lute keep with the careful perspective precepts learned in Lombardy, the softness of the movement of the hands and the life breath drawn through the partially closed lips of the player bring us to the depiction of nature that Caravaggio pursued.

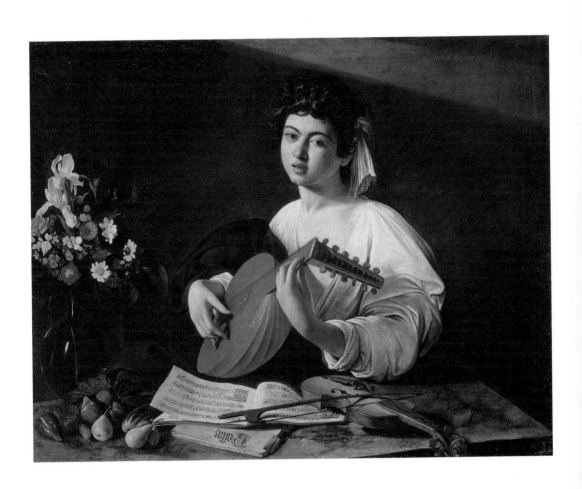

Boy Bitten by a Lizard

1595–1596
Oil on canvas, 66 × 49.5 cm
London, National Gallery

In 1617, Giovanni Baglione noted, "that head actually seemed to cry out." To this day that boy bitten on his fingertip by a lizard that comes out of the still life in the foreground "cries out," wild in his pose and surprised in his expression. The boy's sudden movement, almost certainly painted from life, seems to serve as a pretext to explore studies on expressions, which can likely be tied to the importance of representing 'movements of the soul,' a concept advanced by Leonardo and surely known to Caravaggio from the time of his Milanese training with Simone Peterzano.

While this aspect may have come from Caravaggio's Lombard background, the still life in the foreground shows "a carafe of flowers filled with water in which one could easily distinguish the reflections of a window", part of the optical fidelity to the real developed in Lombardy within Leonardo's scientific tradition, which the life-like depiction that seems to inform the entire composition. The fruits in the burnished colors of green and brown are spread on the table and are visible only through the reflection of light which shines from the left and creates a clean shadow on the background and plays over the forms and surfaces, creating counter light on the dark parts of the boy, clear reflections in the glass vase, and small gleams on the darker fruit, helping to construct their forms.

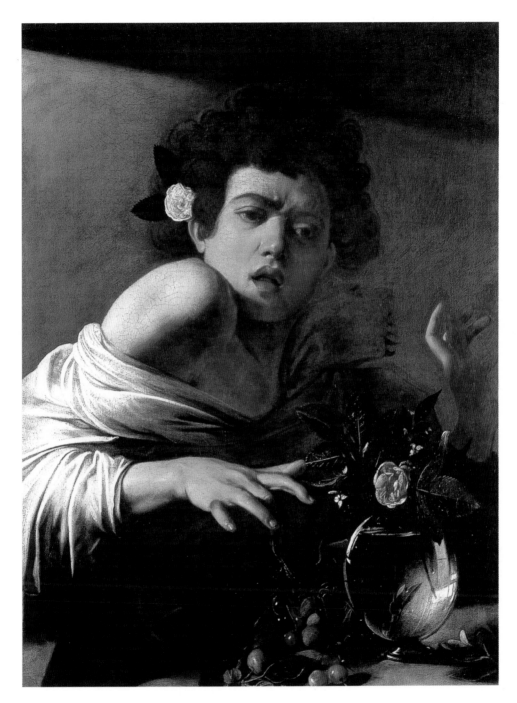

The Rest on the Flight into Egypt

1595–1596
Oil on canvas,
135.5 × 166.5 cm
Rome, Galleria Doria
Pamphilij

According to Giulio Mancini, who wrote about Caravaggio's life ten years after his death, the "Madonna that goes to Egypt" was painted for Monsignor Fantin Petrignani, who lived in the parish of San Salvatore in Lauro in Rome and gave Caravaggio "the comfort of a room" after he left Cavalier d'Arpino's workshop in early 1594. The counter reformist inclination to sparseness in the composition, in which Mina Gregori identified references to Lorenzo Lotto, is placed in a natural landscape without a clear spatial perspective organization. This is matched with a sense of intimacy and domesticity of the depiction of the group tenderly wrapped by the Virgin and the Child and the melancholy of Joseph who holds the sheet music open clearly showing the pages. The clarity with which the notes of the sheet music is shown lets us identify the piece, which must have been chosen to emphasize the composition's religious composition.

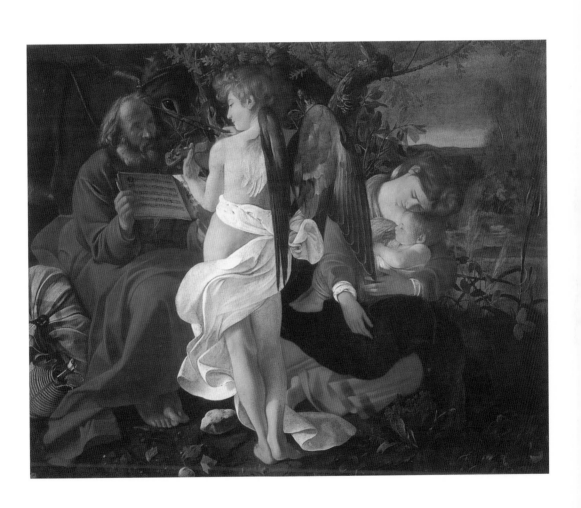

Bacchus

1596–1597
Oil on canvas, 95 × 85 cm
Florence, Galleria degli Uffizi

The portrayal of the pagan divinity to which all of the composition's attributes refer is placed in a clear and bright atmosphere that highlights the truth and naturalness of the model. As radiographs of the painting show, Caravaggio worked to give a greater fullness and regularity to the forms. Far from an interpretation of the classical mythological theme, Caravaggio gave much attention to depicting the natural aspects of this composition.

According to Giovanni Baglione, in 1642, he "made some small pictures of himself drawn from the mirror. The first was a Bacchus with some bunches of various kinds of grapes." Baglione thus describes one of Caravaggio's tools in his process of painting portrayals. Supporting the hypothesis of the use of mirrors for this composition, according to Mina Gregori, is the use of the left hand with which Bacchus offers the cup of wine.

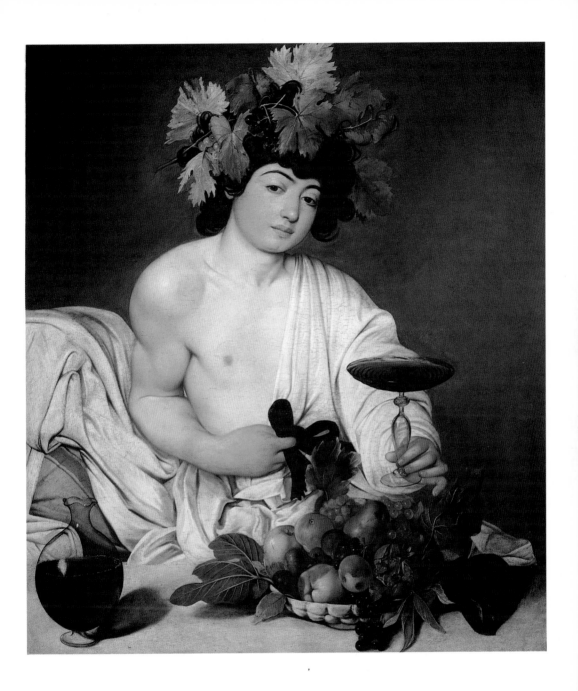

The Fortune Teller

1596–1597
Oil on canvas, 99 × 131 cm
Paris, Musée du Louvre

Painted a few years after *The Fortune Teller* in the Pinacoteca Capitolina in Rome, this is one of the versions held to be signed by Caravaggio, probably painted shortly after he moved to the palace of Cardinal Del Monte. In 1620, this painting was listed among Alessandro Vittrice's paintings by Giulio Mancini, who chose it as the finest example of the principle of 'fidelity to the real' professed by Caravaggio. Bellori recounts: "When the most famous statues of Phidias and Glykon were pointed out to him so that he could use them as models he made no reply other than extending his hand towards a crowd of people saying that nature had provided him with enough masters. To lend authority to his words he called a gypsy who happened to be passing by in the street and after taking her to his lodgings he portrayed her in the act of predicting the future [...] he made a young man place his gloved hand on his sword and offer her the other hand bare to hold and examine; and in these two half-figures Michele captured reality so purely that he confirmed what he had said."

The painting came from the house of Alessandro Vittrice, a member of the same family that years later would commission Caravaggio to paint the *Deposition* (now in the Pinacoteca Vaticana); it passed to the Doria Pamphilij family who gifted it to Louis XIV during Gian Lorenzo Bernini's trip to Paris. Bernini was present at the opening of the case that held the painting when damage was caused to this *Fortune Teller* from water seeping in, irreparably compromising some parts of it.

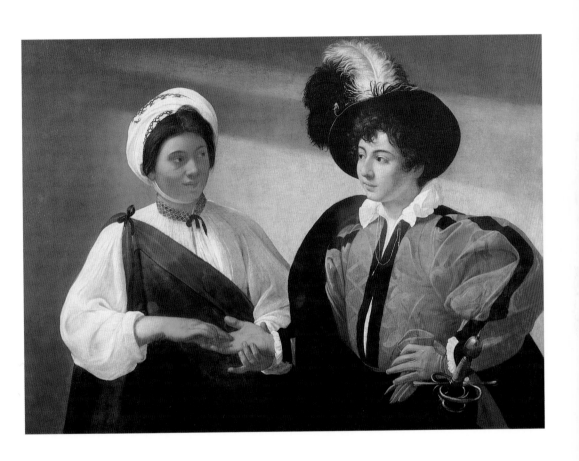

Saint Catherine of Alexandria

1597
Oil on canvas, 173 × 133 cm
Madrid, Museo
Thyssen-Bornemisza

This painting was part of Cardinal Francesco Maria Del Monte's collection in which it was recorded in 1627. The pose of the martyred saint, who we can identify as the courtesan Fillide Melandroni, is enlivened by the mobile expression of her gaze, which, together with the light streaming from the right, gives the depiction a natural quality. The painting dates from Caravaggio's stay with Cardinal Del Monte and his first experiments with depicting expressions and studies on light projected on volumes. It still bears signs of Caravaggio's Lombard roots in the perfect perspective view of the wheel, the careful finishing of the fabrics, and especially in the intense psychological quality of the character that seems depicted rather than represented.

His years at the Cardinal's bore many experiments with portraying "movements of the soul," the expressive changes caused by extreme emotions of anger, fear, or sorrow, which in deference to Leonardo's precepts, saw their highest achievement in the subtle variations of emotions rather than dramatic expressive demonstrations.

Still Life with a Basket of Fruit

1597–1598
Oil on canvas, 31 × 47 cm
Milan, Pinacoteca Ambrosiana

The painting was gifted to the Pinacoteca Ambrosiana in 1607 in the will of Federico Borromeo. In 1599, Federico Borromeo, nephew of the warmongering Carlo, Milanese bishop, was a guest at the Roman palace of the Giustiniani family. These were the peak years of Caravaggio's ascent and the Giustiniani family was busy accumulating works by the artist. Federico Borromeo shared with Giustiniani his great admiration for works depicting still lifes, especially Flemish ones. A work representing this genre of painting in a collection in which still life had a special importance had extra meaning because Caravaggio was an absolute innovator in the Roman scene and because of his Lombard origins.

The clear indication of spatiality, established by the basket's position slightly projecting over the surface on which it is placed, is matched by emphasis on the less fine elements of the individual fruit and leaves. The apple's peel, the split of the ripe fig and the decay of the twisted leaves are elements that bring the composition's tone to fidelity, the naturalness of truth, and its realistic quality that elevates the genre, which was considered inferior, to the level of painting depicting actions, at the time held to be at the top of the hierarchy of painting genres.

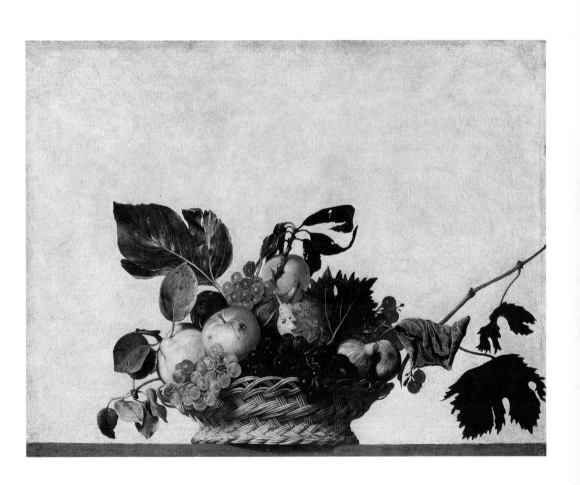

David and Goliath

1597–1598
Oil on canvas, 116 × 91 cm
Madrid, Museo Nacional
del Prado

Far from the erotic/intellectual interpretations developed at the end of the fifteenth century around the figure of David, here Caravaggio portrays him almost as a child, fussing with Goliath's hair. David is intent on making his trophy of the severed head. There is no sign of his future studies on the expressive aspects of acts of violence. It is a quietly abstract interpretation of the myth, perhaps more deferential than the naturalistic and intellectual examples in which naturalness had less to do with depicting raw reality and more with setting myths in an almost bucolic, natural scene with imperfections erased.

The only hint of his future expressive developments is in the left corner where the fist of the decapitated Goliath is still closed. Then, the bent figure of David follows, in its pose, the rectangular profile of the painting balanced on the right edge by the composition of the large head. The light succinctly describes the volumes of the anatomic parts, which in their disdain for drawn preparations are still tied to the technique learned in Peterzano's workshop in Milan. However, the same light makes the profile of David's head emerge in contrast from the background, tying its roots in Caravaggio's early years with his early painting pursuits in Rome.

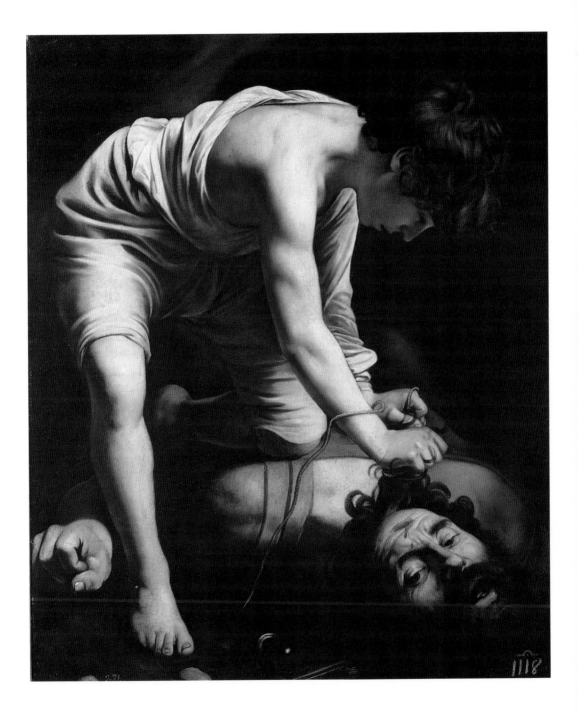

101

Medusa

1598
Oil on canvas on convex
shield, 60 × 55 cm
Florence, Galleria degli Uffizi

Medusa's monstrous gaze turned men to stone. What could be a better device to meet one's enemy with than a depiction of the head of Medusa on a battle shield? This piece was so prized that it was gifted in 1598 by the Cardinal Del Monte to the Grand Duke Ferdinando I de' Medici, for whom he was ambassador to Rome. It may have been so appreciated for the realism of the screaming severed head, which can be tied to classical masks, as well as the fact that its artist was quickly gaining attention in Rome.

Through a perfect illusionistic device based on the careful use of light, shadow, and counterpoints, Caravaggio turned the shield's convexity into seeming concavity, useful for holding the head. The expression's vivacity and pathos are emphasized by the wild, undulating movement of the snakes that surround the extreme expression of the gaze fixed at a single point. The experimentation in extreme expressions can be tied to similar pursuits based on the scientific transposition of nature, of which Leonardo was the finest antecedent. It is noteworthy that in the Grand Duke of Tuscany's collection, a sixteenth-century visitor remembered a Medusa painted by Leonardo.

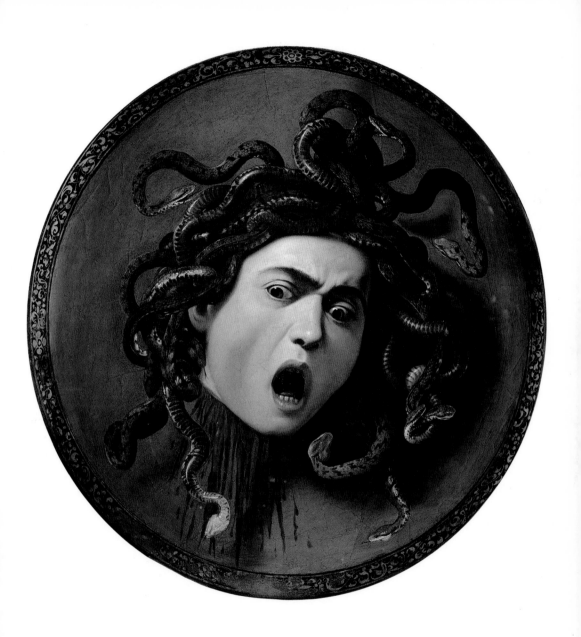

Judith Beheading Holofernes

1599
Oil on canvas, 145 × 195 cm
Rome, Galleria Nazionale
d'Arte Antica, Palazzo
Barberini

Fillide Melandroni was perfect for the role of Judith. The courtesan appeared several times in Caravaggio's paintings in the late sixteenth century. She may have been introduced to him by one of his greatest admirers, the Genovese banker Vincenzo Giustiniani. Fillide and Vincenzo Giustiniani were lovers. It may be more than coincidence that Caravaggio painted this *Judith Beheading Holofernes* for Ottavio Costa, who was also a banker and Genovese and in business with Giustiniani.

Only through painting *historie* could Caravaggio win public commissions to establish himself, proving his ability to handle subjects that were considered at the top of painting hierarchies of the time. His *Judith Beheading Holofernes* was a response to this new demand. The painting combined earlier studies on the transposition of movements of the soul, with roots in Lombard works and Leonardo da Vinci, clear in Judith's look of concentration with the physical tension of the beheading, perhaps even more than in Holofernes's screaming mouth. The two figures are captured in the moment of exertion, watched by the old woman, the symbolic counterpart to Judith's beauty, which has a high precedent in Giulio Romano.

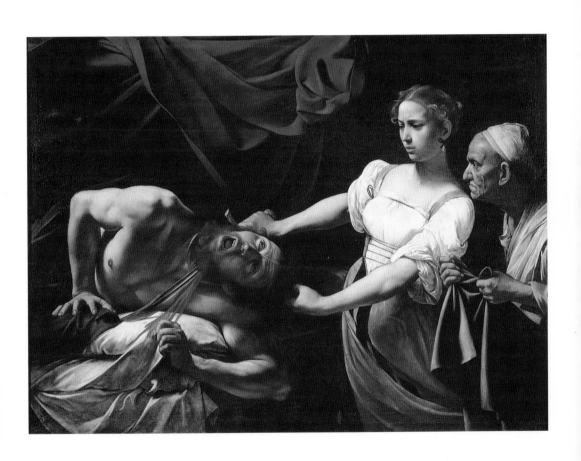

Narcissus

1599
Oil on canvas, 112 × 92 cm
Rome, Galleria Nazionale
d'Arte Antica, Palazzo Corsini

Roberto Longhi has attributed this painting to Caravaggio, though it is not mentioned in any of his contemporary biographies. The interpretation of a mythological theme in the modern era and the naturalness of the pose and Narcissus's expression enamored of himself are certainly themes in keeping with Caravaggio's work.

The painting's vertical format let Caravaggio create an almost perfect double image. Narcissus is a dapper young man with a decorated vest, large puff sleeves, and emerald green trousers, kneeling and stretching towards the water. His arms, bent at angles and reflected, follow the painting's orientation, and his expression of longing can be understood from his profile.

The painting has been dated from his time in the Del Monte palace, when subjects inspired by the daily life in late sixteenth-century Rome were joined by increasing references to themes of classical antiquity. Stylistically speaking, the painting draws from his Lombard repertoire, specifically from Brescia. This is seen especially in the reflected image of Narcissus, painted with pure and soft tonal variations of colors, in the section of sleeves which can be perceived by luminous strokes of light that can be tied back to Savoldo's works, while the figure's profile seems related to Romanino pieces.

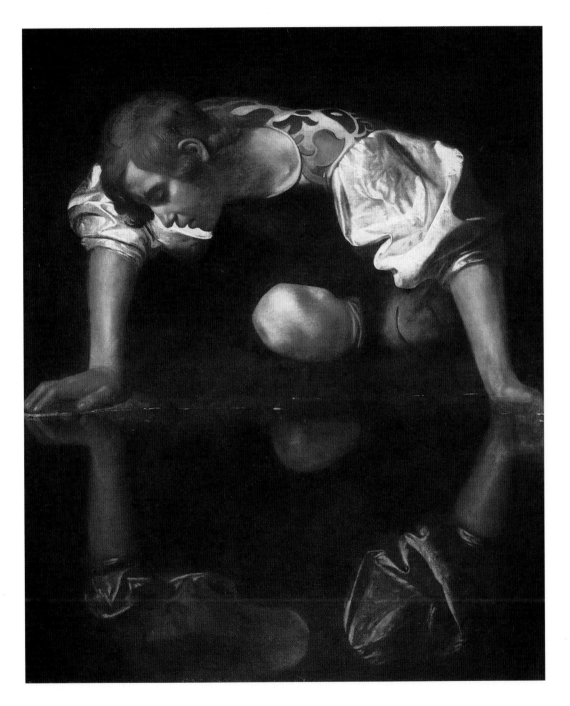

The Calling of Saint Matthew

1599–1600
Oil on canvas, 322 × 340 cm
Rome, San Luigi dei Francesi,
Contarelli chapel

The painting was part of the decoration of the chapel that Mathieu Cointrel, who became Cardinal Contarelli, bought in 1565 in the church of San Luigi dei Francesi. When he died twenty years later, he left his will executor full instructions for the chapel's decorations. The commission for the decoration was originally given to Cavalier d'Arpino who only painted the frescoes on the ceiling. Then in 1599, it was passed on to Caravaggio, probably through the intervention of his protector, Cardinal Del Monte.

Contarelli had described in detail what he wanted: "Saint Matthew in a […] tax collector's office with different things that are needed in such an office with a table like tax collectors used with books and money […]. From that table, Saint Matthew, dressed as was fitting his profession, rises with the desire to come to Our Lord who, passing through the street with his disciplines, calls him."

In taking on his first public commission, Caravaggio had to solve at least two problems: portraying two different physical environments, the 'street' and the 'room', and creating a narrative composition in which several characters depict an action. Caravaggio solved both problems by constructing the scene around Christ's gesture pointing in Matthew's direction and is echoed in the position of Matthew's hand, whose importance is emphasized by the figures that surround him. Christ's symbolic gesture, and the connection between the two groups, is reinforced by the stream of light coming from outside of the visual field, above Christ's head.

The light is an effective symbolic and stylistic device to highlight the apparent historic dissonance between the modern clothes of Matthew and his companions and the few divine attributes of the apostle, barefoot, wrapped in a large classical cloak and Christ, above whose head is the glimmer of a thin golden halo.

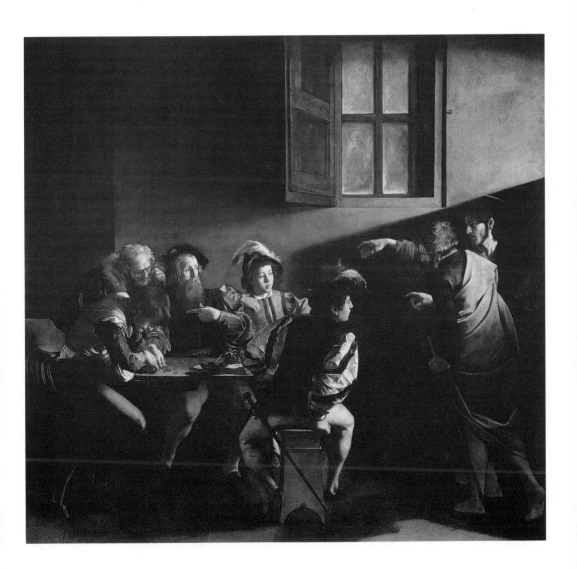

109

The Martyrdom of Saint Matthew

1600–1601
Oil on canvas, 323 × 343 cm
Rome, San Luigi dei Francesi,
Contarelli chapel

Caravaggio was given just a few months to finish the commission for the Contarelli chapel, and he had to deal with depicting a larger number of figures than he had ever painted before. The two works in the Contarelli chapel had to be placed on site for the jubilee year 1600, when pilgrims who would come to visit the church were meant to find it at its best. The instructions for the decoration that Cardinal Contarelli left before his death were clear. Caravaggio was to depict across from the *Calling of Saint Matthew*: "Saint Matthew celebrating mass dressed so that it can be understood that he was killed by the hand of soldiers, and it should be more fitting to have him in the act of killing while he has already received some wounds and has fallen or in the act of falling but not yet dead, and at that moment there is a crowd of men and women, young, old, and angels [...] mostly frightened by the scene, showing in some disdain and in some compassion". After several *pentimenti* whose traces lie under the current composition, Caravaggio organized the martyrdom by making the saint's executioner the pivot point in the act before the final blow. The other figures are arranged around this figure radiating progressively into the depth of the bare space in which the action takes place. Caravaggio's difficult task was in depicting the action. He fixes the dramatic moment before death using light, which streams from the left and organizes the extreme poses of the figures in the depth. It focuses on the nude body of the executioner ready to strike and the gesture of the angel who extends the palm of martyrdom to the saint. The little boy in the act of crying out in terror and turning to flee serves as a counterweight to the central group, while a man, in which a portrait of the artist has been identified, observes the scene from the painting's background.

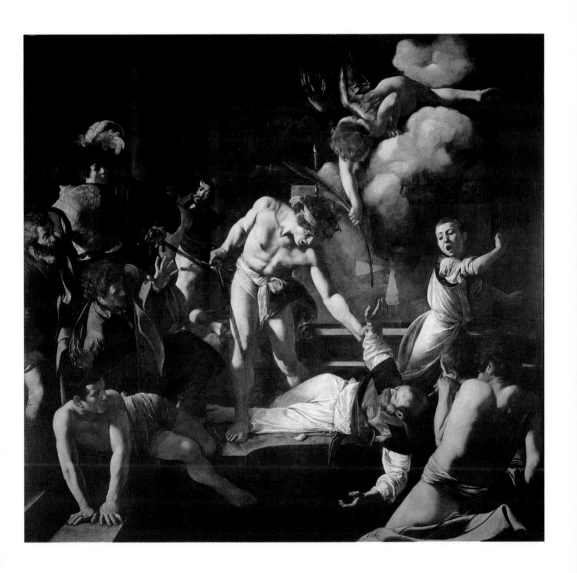

The Conversion of Saint Paul

1600–1601
Oil on canvas, 230 × 175 cm
Rome, Santa Maria del Popolo,
Cerasi chapel

On September 24, 1600, Caravaggio agreed with Monsignor Tiberio Cerasi to paint two paintings depicting the mystery of Saint Paul and the martyrdom of Saint Peter. As had happened in other cases, Caravaggio presented a first version of *The Conversion of Saint Paul*, which was not liked by the Spedale della Consolazione. As Cerasi had died in the meantime, the hospital had become his sole heir and as such had the right to make decisions for the chapel's commission. It is not clear why the first *Conversion of Saint Paul* was refused. Nonetheless, Caravaggio quickly reinterpreted the theme, offering a version without the provocation of the first version.

Caravaggio stayed true to the text of Saint Paul. He rendered the theme of the conversion in an atmosphere of quiet suspension, giving the religious event a fully interior space.

The composition is set in the warm atmosphere of a stable and appears dominated by the naturalness and calm of the horse managed by the groom. It is contrasted by Paul's foreshortened pose with his arms wide to take in the divine revelation represented by the light from the upper right-hand corner, the only concession to the supernatural.

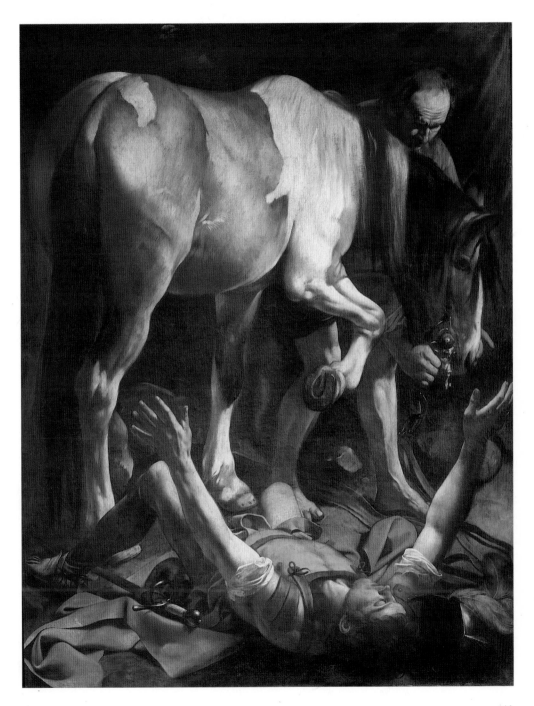

The Crucifixion of Saint Peter

1600–1601

Oil on canvas, 230 × 175 cm
Rome, Santa Maria del Popolo,
Cerasi chapel

Like *The Conversion of Saint Paul*, the first version of *The Crucifixion of Saint Peter* for the Cerasi chapel in Santa Maria del Popolo in Rome was rejected. In fact, the contract for the commission, which Caravaggio signed on September 24, 1600, required the presentation of a diagram or a model before completing the final decoration. It is possible that he immediately painted two final versions of the theme without presenting any plan, and that they were therefore not accepted. Or, though it may have been accepted by Tiberio Cerasi, who had specifically chosen Caravaggio for his chapel, it may not have been to the liking of the Spedale della Consolazione which, after Cerasi's death, was in charge of his affairs. At any rate, Caravaggio resolved this version of the *Crucifixion*, as well as its partner painting, around the theme of "stoic and meditative calm" and as such organized the compositional economy on a few orienting diagonal lines, used to capture the quiet muscular tension of each of the three executioners and Peter's intent expression. The clean light focused on the close compositional angle is contrasted to the dark background. The light describes the powerful volumes, caresses the earthy tones, makes the whites of the clothes shine, and throws strong shadows on the ground where the martyrdom's symbols are depicted.

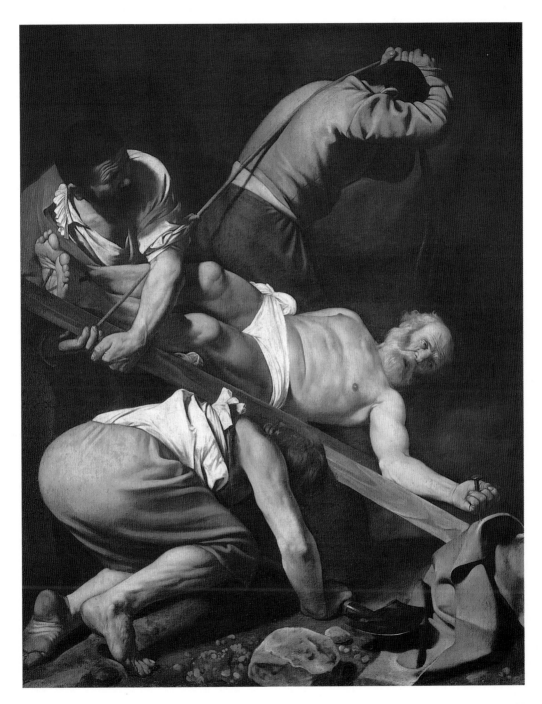

The Incredulity of Saint Thomas

1600–1601
Oil on canvas, 107 × 146 cm
Potsdam-Sanssouci, Stiftung
Schlösser und Gärten

In 1606, Vincenzo Giustiniani referred to this painting when he mentioned a copy in Genoa. Twenty years later, *The Incredulity of Saint Thomas* was among the inventory of his collection, making it plausible that he commissioned the work, which the sources also put forward as a possibility. In fact, he had to have been one of Caravaggio's closest supporters to accept the cold brutality of this portrayal.

The painting's horizontal format frames three quarters of the height of the four figures centered against a completely bare background. This emphasizes the geometric arrangement of the group, with Thomas and the two onlookers in a position opposite to Christ. The crude sticking of the finger in the bloody wound of the Christ figure, influenced by classical sculpture in his chest and the draping of the white chiton, is highlighted by the light projecting from left to right and the paring down of the painting's elements to the bare essentials. The geometric balancing of the four figures leads us to recognize both a careful compositional plan in them and a symbolic relationship that connects each symbolically to the other. The four-leaf clover arrangement of the heads of Christ, the saint and the two other figures is significant.

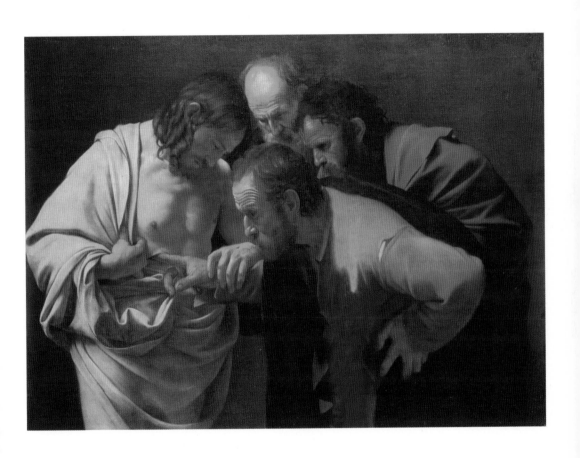

Supper at Emmaus

1601
Oil on canvas, 141 × 196.2 cm
London, National Gallery

This *Supper at Emmaus* was much admired among the works that Caravaggio painted for Ciriaco Mattei. Caravaggio probably started work on it in the autumn of 1601 when, based on documented evidence and information from sources, he lived with his servant Cecco in Mattei's household.

Perhaps it was the "terrible naturalism" that Scannelli noted in the painting in 1657 that earned it acclaim. The painting depicts the moment in which the three disciples recognize the arisen Christ in their table companion while Christ blesses the bread. In addition to his customary fidelity to reality with the modern clothes of the three disciples and the basket of fruit tilting towards us, Caravaggio ties the interpretation of the event to symbolic references that would have been easy to decode at the time, but are obscure to us today. A flat and natural language informs this composition, far from Counter-Reformation language. It consists of precise symbols, the choice of the elements depicted on the table and simple, but eloquent gestures. Once again, it is light to unify the natural world, with the optical veracity that can be found in such passages as the ring of light on the tablecloth under the glass pitcher. It also emphasizes the gestures, which again have a more important role than that given to the gazes, as seen, for instance, in Christ's arms stretched forward.

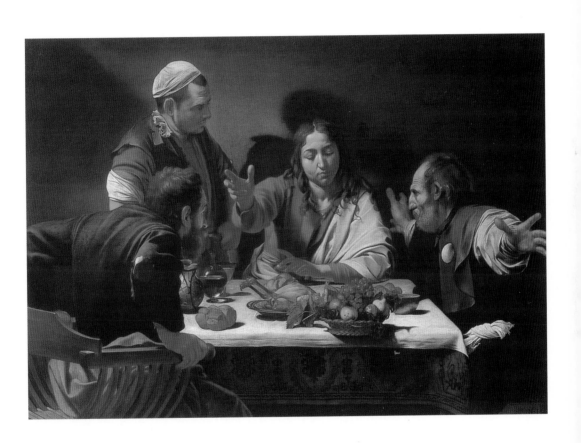

119

Saint Matthew and the Angel

1602
Oil on canvas, 295 × 195 cm
Rome, San Luigi dei Francesi,
Contarelli chapel

After the extraordinary success of the side paintings that Caravaggio had painted for the Contarelli chapel, the altarpiece was also commissioned to Caravaggio, though two years later. He completed it in three and a half months for the price of one hundred and fifty scudi.

Caravaggio stayed true to the instructions that Cardinal Contarelli had left before his death about what he wanted depicted in the chapel's decoration. Though Caravaggio depicted on an altarpiece Saint Matthew seated "with a book or a volume" intent on writing the gospels, "and next to him an angel standing, beyond natural, who acts in what seems to be reasoning or in another attitude", the first version of *Saint Matthew and the Angel* was rejected by the congregation and immediately bought by Vincenzo Giustiniani for his collection. As Giovan Pietro Bellori would explain in 1672, "the central picture of Saint Matthew [...] was taken away by the priests. The figure had neither decorum nor the appearance of a saint they said, as it was sitting with its legs crossed and its feet rudely exposed to the public." Though "Caravaggio was in despair at such an outrage," he had to get to work on a second version of the same subject, the one which is now found in the Contarelli chapel. The second version of *Saint Matthew* appears radically different than the first one. The two figures of the saint and the angel are placed along a surface raised at the base of the composition whose volume is perceptible only because the stool on which the old saint rests his knee is hanging across it, turned outwards. Matthew is no longer a peasant, but a figure cloaked in the wisdom of age, and the angel flies from above, stops, and seems to be debating with the Evangelist with a gesture taken from rhetoric.

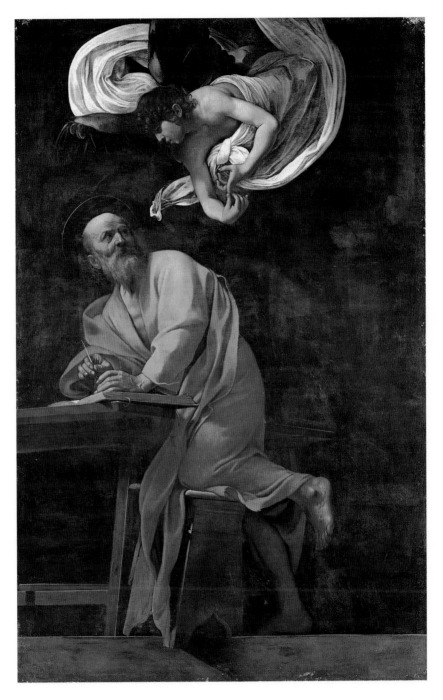

The Betrayal of Christ

1602
Oil on canvas, cm133.5 × 169.5
Dublin, Society of Jesuits of
Saint Ignatius, on loan
to the National Gallery
of Ireland

On January 2, 1603, Ciriaco Mattei paid one hundred and twenty-five scudi for a *Betrayal of Christ* in the garden. Only recently was this work, now in Dublin, recognized as the original that had been thought lost.

The episode is of Judas's betrayal resulting in Christ's capture in the dark of the night by Roman soldiers.

Caravaggio represented it by placing the emotional peak of the scene on the three variations of Christ, Judas, and Saint John fleeing, whose face is captured in a three-fourths profile crying out, seeming to herald the passion that will follow the capture of the Messiah. The large red cloth, the only bright component of a color spectrum mainly limited to spare tones of black and ochre, highlights the dramatic quality of the expressions of the faces framed to the left of the composition's fulcrum. The unbalancing that results, partly directed by the gleaming on the soldier's black armor, highlights the dynamic sense of the whole.

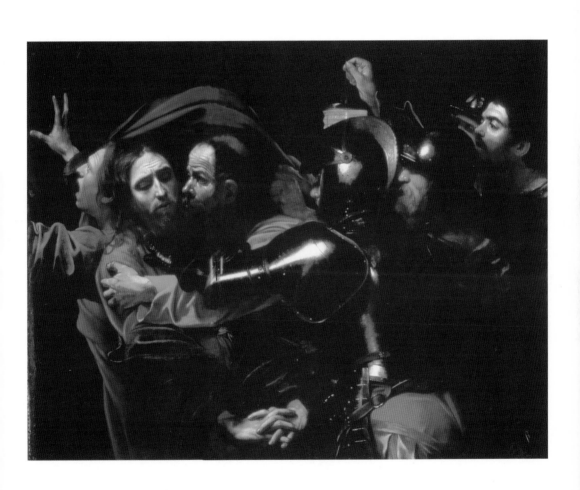

Cupid

1602–1603
Oil on canvas, 156 × 113 cm
Berlin-Dahlem,
Gemäldegalerie, Staatliche
Museen, Preussischer
Kulturbesitz

In 1630, Vincenzo Giustiniani had an inventory drawn up of his extensive collection. Its administrator, Joachim von Sandraart, noted that among Caravaggio's fifteen works in the collection, there was one he considered truly exceptional: "This piece was shown publicly in a room together with another 120 paintings by the most outstanding artists; but at my suggestion it was given a dark green silk covering and only when all the others had been seen properly was it finally exhibited because it made all the other rarities seem insignificant." He was writing about the *Cupid*, now hanging in Berlin, which Caravaggio is likely to have painted between 1602 and 1603 for Vincenzo Giustiniani. Fifty years later, an English art connoisseur named Richard Symonds visited the marquis's collection and made some interesting notes on the painting. From Symonds, we know that astounding sums were offered to buy the painting, and that Cecco Boneri, Caravaggio's young servant who would become a painter himself, had posed for the painting.

The painting, which Giustiniani had purchased for three hundred scudi and which was later assessed at ten to fifteen times that, was considered an undisputed masterpiece, to the extent that many avant-garde poets dedicated madrigals and epigrams to it. Based on Sandrart's writing, what struck contemporaries the most was that in the *Cupid* all is "drawn correctly with such powerful coloration, clarity, and relief that it comes to life."

Indeed life may be the painting's finest aspect, with Cecco's lively expression caught in a natural, wayward pose somewhere between winking and smiling, and the playful, unsteady movement of the legs and arms typical of early youth.

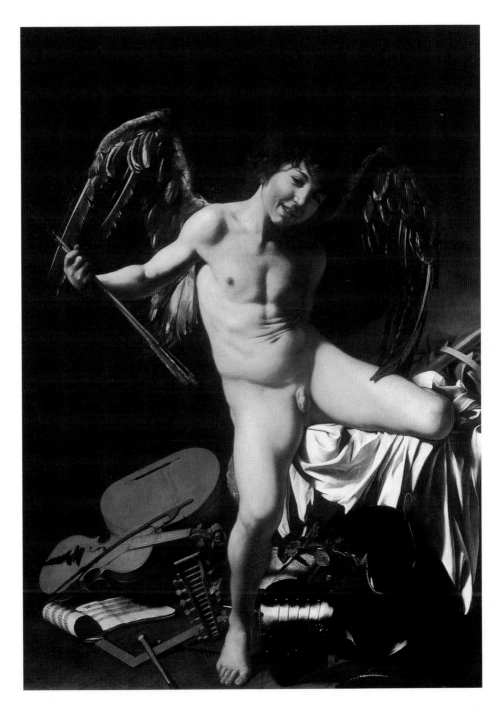

Saint John the Baptist

1602
Oil on canvas, 132 × 97 cm
Rome, Pinacoteca Capitolina

A few years after this painting was made around 1602, it was still in the house for which it had been commissioned. A document from 1601 establishes that Caravaggio was living at Palazzo Mattei in Rome in that year. The many works that Caravaggio painted for the Mattei family in that period has bred the theory that Caravaggio actually spent considerable time with the family.

It has not yet been definitively clarified if the subject depicted is actually Saint John the Baptist, in honor of the eldest Mattei son who was named John, or if the painting could be seen as portraying a different theme, as suggested by new research based both on the fact that it was not titled even in Mattei inventories and on the importance of the adolescent's smile in the composition.

The family's special interest for classical statues seems to be echoed both in the softly contrasted pose and in the late Alexandrian attention for Saint John's young body. The naturalistic attention to the surfaces, the saint's tender skin, the ram's coat and the realism of its horns match their classical roots with Caravaggio's principle of "fidelity to the real", as he captures the adolescent's vivacious appearance, including the half smile he puts on him.

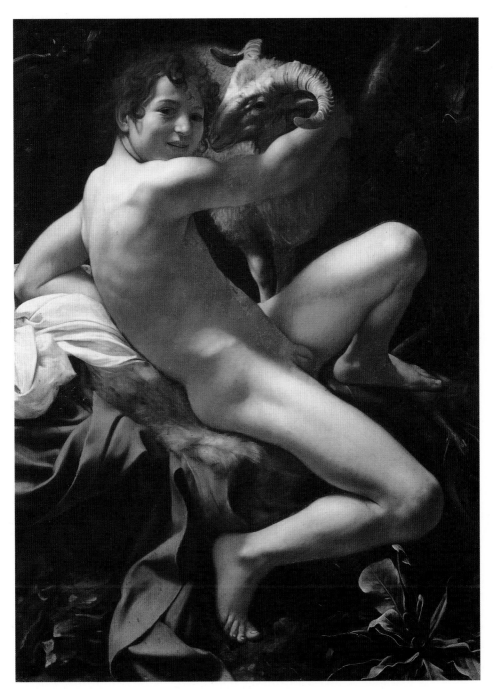

Deposition

1602–1604
Oil on canvas, 300 × 203 cm
Vatican City, Pinacoteca
Vaticana

Pietro Vittrice, the majordomo and *guardarobiere* of Pope Gregory XIII, died in early 1600. He had a chapel in the new church of Santa Maria in Vallicella and his nephew Girolamo had commissioned Caravaggio for an altarpiece between 1601 and 1602. The chapel was closed in early 1602 to be reopened in 1604 with the painting of the *Deposition* on the altar. This was one of Caravaggio's very few public works to be unanimously admired, most likely because of the open references to classical and sixteenth-century models, including Raphael's *Deposition*, as suggested by Mina Gregori.

As Bellori noted in 1672, "all the nude parts [of Christ] are portrayed [by Caravaggio] with the force of the most precise imitation." In this case imitation is not just fidelity to the real; it is a portrayal filtered through classical statues, as seen in the arm falling on the tombstone, which even the detractors of Caravaggio's work said was as it should be.

Christ's pale body is held by Saint John and Nicodemus. Behind them, the Virgin, Mary Magdalen and one of the holy women are depicted in a pyramid arrangement that ends in the raised arms of the woman with her contorted face turned to the heavens. The corner of the stone in the foreground illusionistically forms a base, supporting and developing the entire sculptural group.

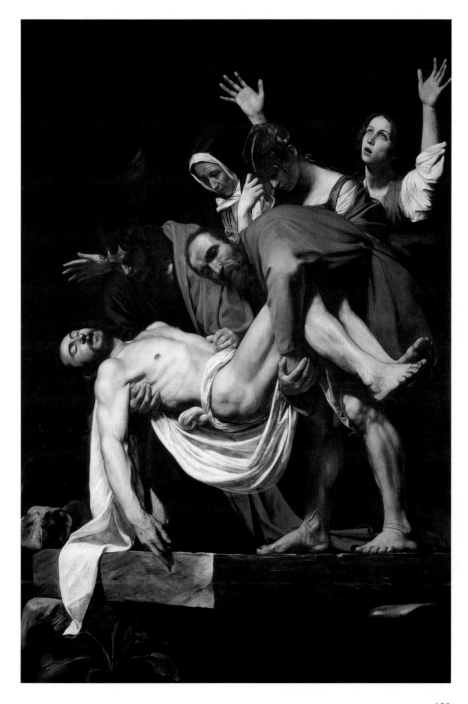

The Crowning with Thorns

1603
Oil on canvas, 127 × 165 cm
Vienna, Kunsthistorisches
Museum

In 1638 this painting figured among Vincenzo Giustiniani's collection, though its dating is still controversial. Some say that the painting was from Caravaggio's last years. Others place it closer to the works made for the Cerasi chapel featuring a use of light somewhere between the contrasted light of the Betrayal of Christ in Dublin and the softly diffused light of *The Incredulity of Saint Thomas* in Potsdam. Elements that tie it to the Cerasi paintings for Santa Maria del Popolo include the solid compositional organization of the diagonals (by the flagellators) and the event's interpretation in an atmosphere of quiet immobility in which the theme's essence can be seen in Christ's expression of inner acceptance of suffering. The light, which is diffuse but falls from the top left, is a forerunner of later compositions constructed exclusively on the variation of burnished browns and the earthy tones of the color spectrum. Here, the colors are enlivened by the powerful red that frames Christ, the gray and black of the knight's armor, and the brilliant whites of the feathers on his hat, the shirt of the jailer behind Christ, and the band wrapped around his head.

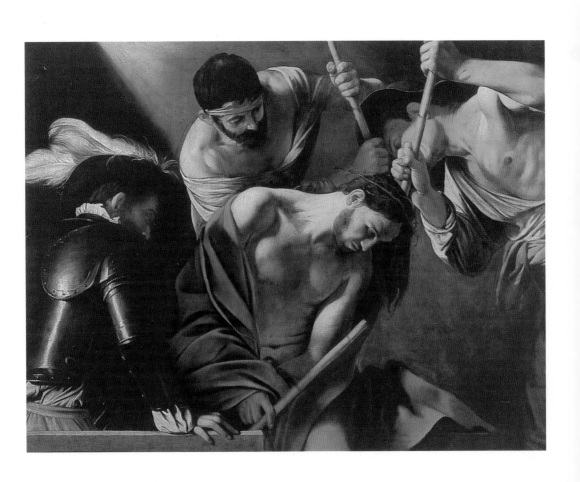

The Sacrifice of Isaac

1603–1604
Oil on canvas, 104 × 135 cm
Florence, Galleria degli Uffizi

After having his portrait painted by Caravaggio, Cardinal Maffeo Barberini, the future Pope Urban VIII, asked him for this *Sacrifice of Isaac*. The payments for the piece were all listed between May 20, 1603, and January 8, 1604, in Cardinal Barberini's account books. They show an interruption in payments during the summer, which is evidence of the slander trial that Baglione had brought against Caravaggio. Caravaggio was meant to complete the work for Barberini only after he got out of prison on September 25. In all likelihood, it was during his house arrest that he returned to work on this *Sacrifice of Isaac*. The work is a further instance of Caravaggio's studies of the dynamic of extreme expressions associated with acts of violence. Isaac, captured in the expressive immediacy of his scream of terror, is again Cecco Boneri, Caravaggio's servant, who later became a painter himself. He appeared in many paintings from this period. Cecco did not only pose for Isaac; recent reflectographs show that Caravaggio also used him as a model for the angel and than changed the profile and hairstyle to conceal his features. This helps us imagine how Caravaggio proceeded in developing his paintings, building the compositions by process of addition, creating the figures through studies made directly from models.

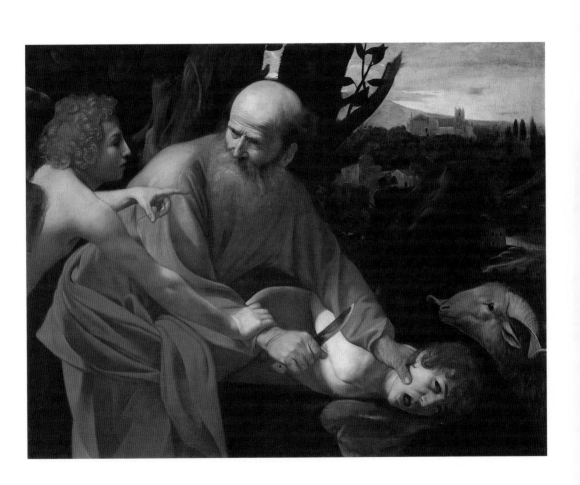

Death of the Virgin

1604
Oil on canvas, 369 × 245 cm
Paris, Musée du Louvre

On June 14, 1601, Laerzio Cherubini commissioned Caravaggio for a painting for the altar of the chapel that he had bought in the church of Santa Maria della Scala in Rome. The Carmelites had dedicated the Cherubini chapel to the Virgin Mary's journey to heaven, and they held masses here for the deceased. Though there is no surviving document telling us when the work was completed and delivered, Caravaggio must have worked on it around 1604, well past the contract's deadline. As soon as this painting, the largest that Caravaggio had ever painted in Rome, was placed in the church in Trastevere, it was immediately removed. This was another in a long line of rejections for Caravaggio.

For the faithful it was unthinkable to be faced with a scene of grief so close to the contemporary age, a Virgin so like the women of the people of Rome in the early seventeenth century; a Madonna completely lacking in divine attributes, save the thin golden halo behind her head, could not be accepted. Yet was this the reason for its rejection, or was it as Caravaggio's biographers reported, that the friars had the painting removed because Caravaggio had "portrayed as Our Lady a courtesan he loved", or because he "portrayed the Madonna with little decorum swollen and with bare legs," "a common dirty whore"? We cannot know for certain. At any rate, the painting raised interested in the era's intellectual artistic world, so that the painters of Rome let it be shown to the public before it was moved to Mantua at the court of Duke Vincenzo I Gonzaga.

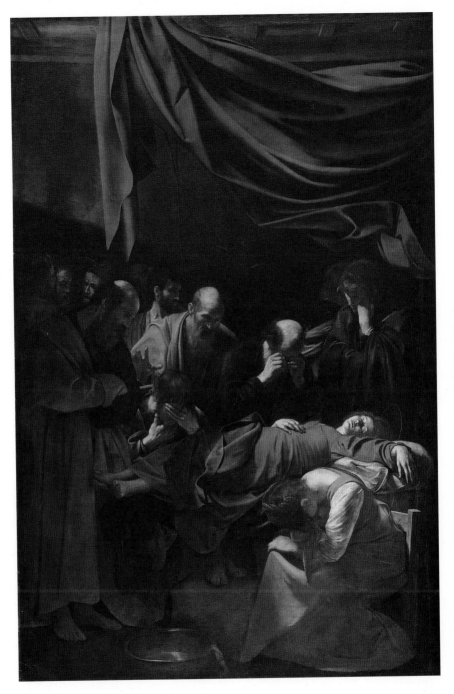

Madonna of Loreto

1604–1606
Oil on canvas, 260 × 150 cm
Rome, Sant'Agostino,
Cavalletti chapel

A woman of the people, with her child in her arms, is waiting at the door of her house, a typical Roman house, and in front of her are two wayfarers dressed in rags, with bare dirty feet and patched clothes; the only signs of their condition are their clasped hands and two pilgrim staffs. This was the result of Ermete Cavalletti's legacy for the church of Sant'Agostino in Rome. As Baglione wrote around 1620, after it was placed on the altar, "the populace made a great fuss" over the painting.

In the painting, Caravaggio's sophisticated dedication to the real which led him to even portray the pilgrim's soiled feet is matched by his taking up as counterpart a composition derived from a very popular Titian model, who was also an inspiration for the velvety red seen in the Madonna's bodice. These subtle references could not have had much meaning for the public at large, as it would have been equally little understood that the Madonna's pose, as well as her profile, were inspired by classical statues. This was not for lack of good intentions or mere ignorance; the fact was that the languid pose, that natural quality of the body, fit well with the primary activity of the woman who had posed for this painting with her child: Maddelena Antogneti, known as Lena, a well-known figure in the city. She had been the lover of many powerful men and her life as a courtesan had also recently got her in trouble with the law. One of the reasons behind the great 'fuss' by the populace, alongside the higher philosophical and religious questions, must have been the difficulty of accepting themselves in prayer in front of a figure that was so little associated with the essence of spirituality.

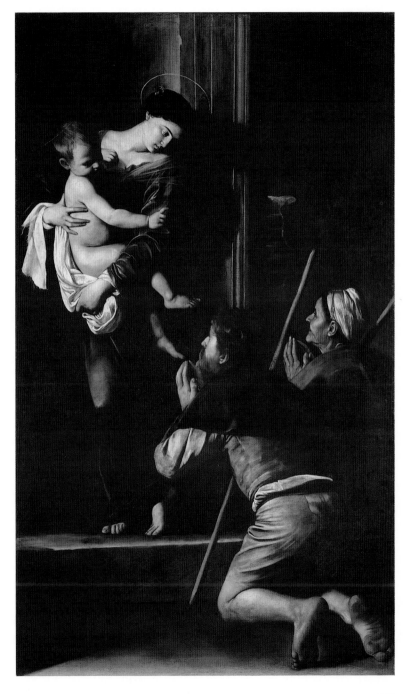

137

Madonna of the Palafrenieri

1605–1606
Oil on canvas, 292 × 211 cm
Rome, Galleria Borghese

During the completion of the construction of Saint Peter's church, which had been opened for at least a century, the chapel of the papal Palafrenieri was moved and needed a new altarpiece. The Palafrenieri chose Caravaggio and wanted an altarpiece depicting the figure of Anne, their patron saint and mother of Mary. In accordance with client instructions, Caravaggio portrayed Mary and the Child in the act of crushing the serpent of original sin in Anne's presence. Caravaggio gave the scene the domestic nature that is seen in some Lombard altarpieces from the previous century.

As we know from a receipt written in Caravaggio's hand, the altarpiece was completed on April 8, 1606. Around that date the Palafrenieri placed it temporarily in a chapel dedicated to Saint Michael the Archangel. Perhaps because no chapel was then ever actually dedicated to the Palafrenieri, the work was given to the Cardinal Scipione Borghese.

The painting received an enthusiastic response from the cultural circle close to Caravaggio. He painted it when he was in the house of his friend Andrea Ruffetti. The poet Marzio Milesi dedicated some verses to it, and Giovanni Castellini wrote an epigram commemorating its completion. Castellini was an archeological expert and Anne's pose seemed to him inspired by an ancient Greek sculpture that had recently been uncovered in the Roman area. The 'high' reference of Anne and the Madonna and Child's naturalistic pose is a counterpoint to the use of Lena Antognetti yet again as a model for the figure of Madonna. The tempestuous life of this woman, portrayed in all of his religious altars of this period, caused none too few legal problems for Caravaggio.

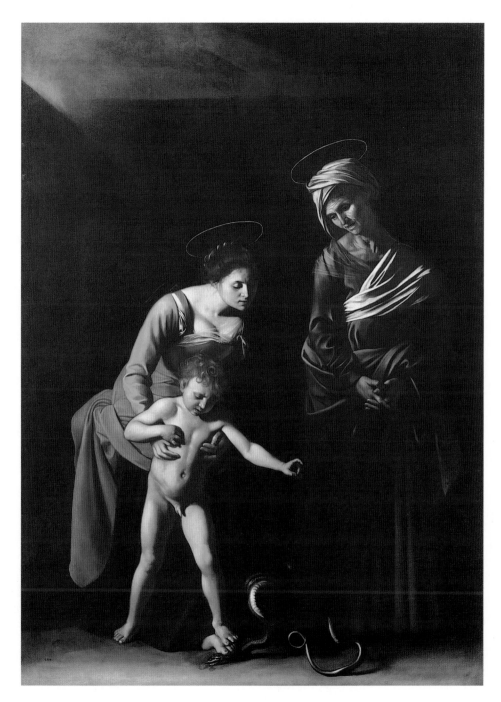

Saint Francis in Meditation

1605
Oil on canvas, 128 × 97 cm
Rome, chiesa dei Cappuccini

This painting is not mentioned in any known documents. Until writing on this painting was published, critical debate centered on a similar painting of Santa Maria della Consolazione connected to Caravaggio's period of transit between the Colonna estates in 1606. The *Saint Francis in Meditation* anticipated some of the style and technical features that would be part of Caravaggio's Sicilian and Neapolitan works. It is almost a summary of his works immediately preceding it, showing its clear Counter-Reformationist expression in a mythical Jesuit tone proper to Capuchin Franciscans. The cross on a stone seems to underline the concept of sacrifice. The entire image is built in an atmosphere of *ars moriendi* (the art of dying). The saint is depicted in the typical pose of melancholy uncommon in Italian culture of the late sixteenth and early seventeenth centuries.

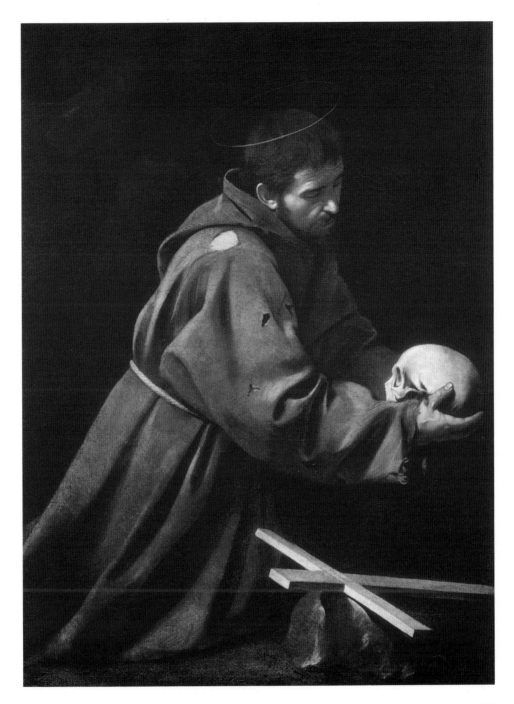

Saint Jerome

1605–1606
Oil on canvas, 112 × 157 cm
Rome, Galleria Borghese

In 1672, Giovan Pietro Bellori included this work among those painted for Cardinal Scipione Borghese. It is dated between 1605 and 1606. The saint was one of the favorite figures of Counter Reformation art, likely because he translated the Bible from Hebrew to Latin, contributing to the spread of the religious word.

Caravaggio arranged the theme in a horizontal three-fourths format, composing the scene like an abstract still life in which the figure of Saint Jerome plays the same role as the paper, the parchment of the books, the wooden table with the skull, and the pen. Similar to the development of the still life genre in the Flemish tradition, each of the elements has a specific symbolic meeting, also based on its placement. As such, the spatial relationship between the skull and Saint Jerome's inclined head is not accidental. Its compositional economy is perfectly balanced by the arrangement of the elements along the horizontal and vertical axes. The composition's sparseness is matched by an equally spare variety of colors, a wide spectrum of burnished and golden browns in which the purity of the red of Saint Jerome's cloak stands out along with the white of the cloth underneath the books.

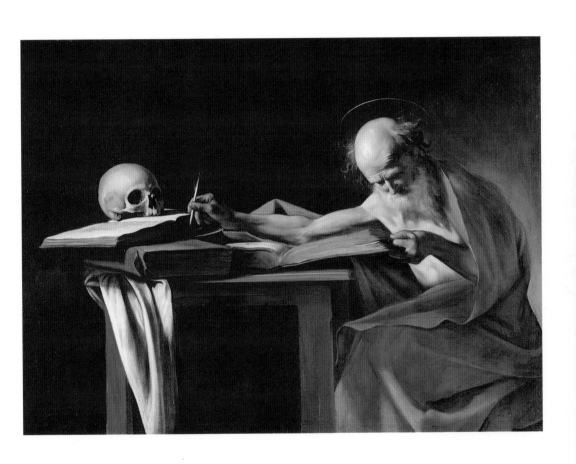

Saint Francis in Prayer

1605–1606
Oil on canvas, 130 × 90 cm
Cremona, Pinacoteca
del Museo Civico

The kneeling saint is captured from the front while he contemplates the cross, which is foreshortened crosswise and resting on an open book. A skull is supporting the book in the foreground, placed in the composition's left corner. The small group of objects is treated like a still life with specific reference to the theme of vanitas. The saint's curved pose, with his head resting on his clasped hands, adds to the atmosphere of inner concentration of his mediation in a clearing in the woods, which is shown by light on the trunk that is part of vegetation made through subtle tonal passages between light brown, dark brown, and black; it comes through the reddish preparation of the background that brings out the earthy colors of the entire composition. The light intensifies the expressive creases of the saint's face concentrated in meditation and his clasped hands. The light also brings out the cloth of the tunic of the figure, organized in geometric volumes, and light is also part of the details of the still life, expressing the foreshortening of the cross, the bright edge of the book's open page, and the skull's features.

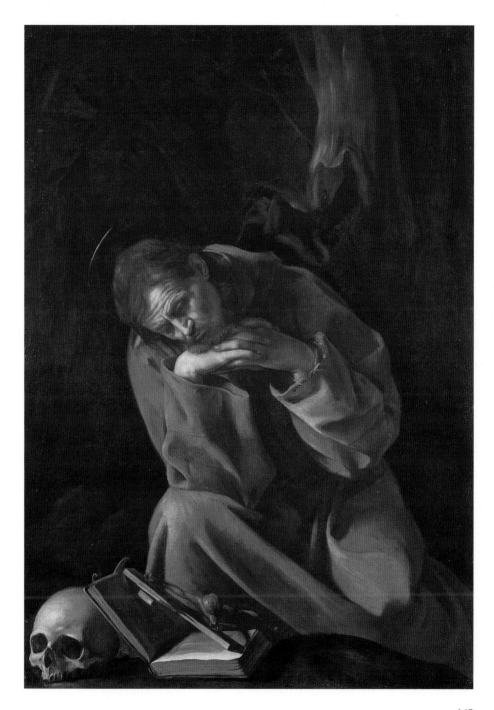

David with the Head of Goliath

1605–1606
Oil on canvas, 125 × 100 cm
Rome, Galleria Borghese

Three fourths of David emerges from darkness; sword still in hand, he is proudly intent on observing Goliath's head, which he displays, still bleeding, after his beheading.

The head, in which Caravaggio's self-portrait has often been identified, is still vividly expressive, despite having already been severed. The emotional sensibility of the wrinkled brow, of the mouth open to draw its last breath, and the powerful suffering look of Goliath likewise inform David's torso and facial expression. The brown trousers and ripped shirt that cover him are pieces of superior painting, a synthesis that uses long separate brushstrokes, and pairs the pure whites and grays in the shirt with an effect of transparency and tones of Lombard origins.

The still–legible letters that appear along the edge of David's sword have been linked by Maurizio Marini to a puzzle that must have been easy to solve for the recipient of the work as well as for those at the time that were familiar with religious emblems. In Goliath's head, Marini recognized the humble, anti-hero, Christological portrayal of the myth as an emblem of evil. He also identified the letters engraved in the sword's blade, an instrument of justice, as correlating to the motto: 'H(UMILIT)AS O(CCIDIT) S(UPERBIAM) (Humility kills haughtiness), and related it to the painting with the four puzzle paintings in which musical pieces are depicted from Caravaggio's Roman period.

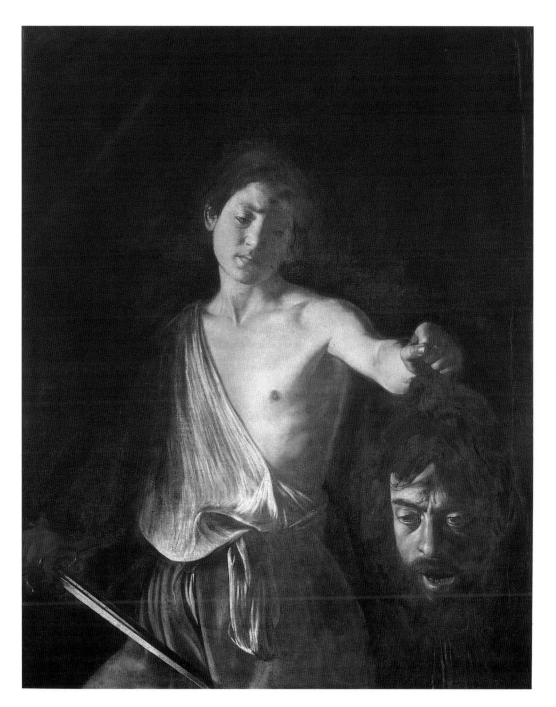

Supper at Emmaus

1606
Oil on canvas, 141 × 175 cm
Milan, Pinacoteca di Brera

This painting is among the few that Caravaggio painted in the four months that he spent at the Colonna estates in Zagarolo and Paliano. This was the period immediately after he murdered Tomassoni in 1606.

According to Giovan Pietro Bellori, the Marquis Patrizi commissioned this work to Caravaggio, requesting "for the Marchese Patrizi the Supper at Emmaus where Christ is in the centre blessing the bread and one of the seated apostles stretches out his arms in recognition and the other rests his hands on the table and stares in astonishment; behind are the innkeeper with a cap on his head and an old woman who brings food."

As Maurizio Calvesi noted, this one differs from the *Emmaus* in London in that here Caravaggio presented the moment after the religious act, when the bread has already been broken and the gesture of blessing signifies an ending. This Christ seems older than the young beardless Christ of the London *Emmaus*.

The light enunciates the volumes, contrasting them with the dominant earthy tones of the background. The painting is part of his rapid, spare style, and scarcely more detailed than a first draft, which here helps achieve an emotional result that highlights the essential values of the subject and its emotional resonance.

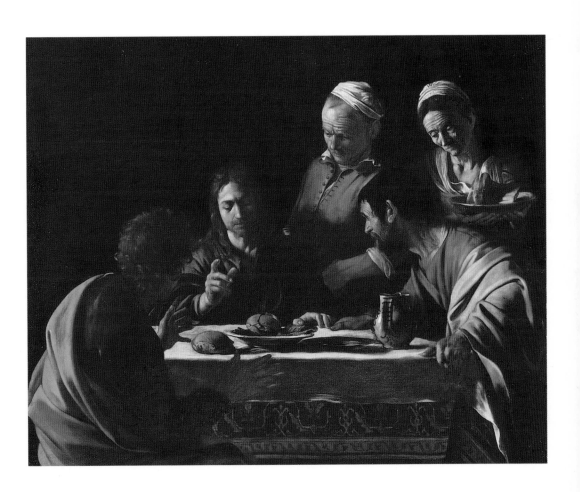

Madonna of the Rosary

1607
Oil on canvas, 364 × 249 cm
Vienna, Kunsthistorisches
Museum

This work was presumably painted for the Carafa Colonna family after Caravaggio, fleeing from Rome after the murder of Ranuccio da Terni, came to Naples around end of the 1606. The panting was sold in Naples and bought by the painter Louis Finson, who moved it to the Netherlands. Here, after Finson's death, it was bought by a group of artists led by Pieter Paul Rubens for the Dominican church of Saint Paul in Antwerp. It then went from the church to Joseph II of Austria and to the museum in Vienna where it hangs today.

The composition is theatrically composed under a large swath of a tied red curtain where the Madonna with Child is sitting elevated above Saint Domenic and the martyred Saint Peter to the sides. The three Neapolitan barefoot lepers are at their feet with their hands outstretched. Next to the lepers, whose gaze is towards the Madonna with Child, a young mother and her daughter are kneeling, and almost crushed against the painting's edge with his head turned towards the viewer, is a middle-aged man dressed in black with a white ruff, probably the painting's client.

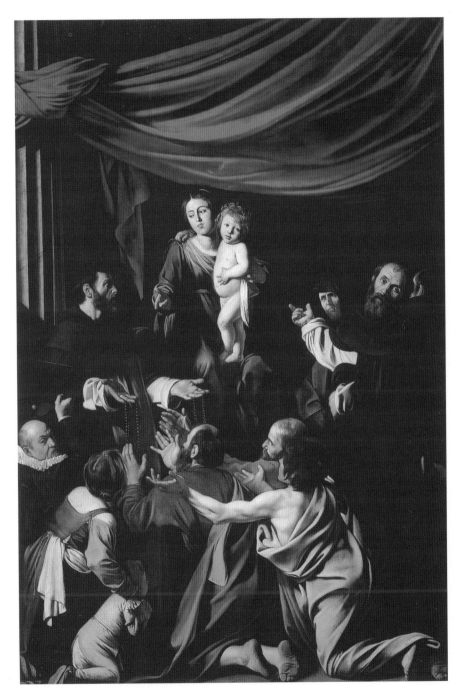

David with the Head of Goliath

1607
Oil on panel, 90.5 × 116.5 cm
Vienna, Kunsthistorisches
Museum

This David was the last panting in which Caravaggio painted his servant, Cecco Boneri. The half figure was painted in early 1607 in Naples on wood over an old mannerist allegory.

The composition depicts the young hero of the myth immediately after cutting off Goliath's head, brought as a trophy after the battle. Similar to the figures in the Madonna of the Rosary, the light elucidates the synthetic volumes and crosses over the surfaces almost flatly, highlighting the fixed gesture of David, whose distant expression is contrasted with the dramatic tension of Goliath, who is closer to the highest models of Caravaggio's Roman period. His half open mouth shows the gleaming of his teeth, his half closed eyes and the furrow between his eyebrows along with the creases in his cheeks and sticky hair are in the tradition of the studies of expressive representation of 'movements of the soul' rooted in Leonardo.

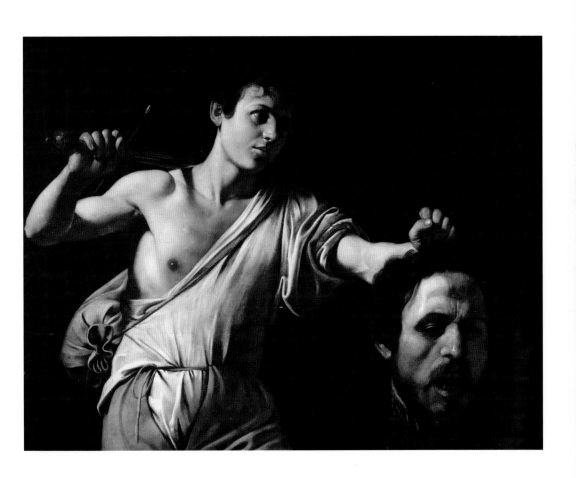

The Seven Works of Mercy

1607
Oil on canvas, 390 × 260 cm
Naples, Pio Monte della
Misericordia

Of Caravaggio's Neapolitan works, this painting that he made for Pio Monte della Misericordia was undoubtedly his most prestigious public work. The congregation consisted of young aristocrats from the city who wanted to portray the seven works of mercy on a large altarpiece: the six works enunciated by Christ in the Gospel of Matthew and the burial of the dead which after the recent plague had become a critical problem for Naples. The painting was intended for the church's main altar and a fee of four hundred ducats was paid for it in 1607.

In a very short time, Caravaggio portrayed the seven works, presenting a complex and animated theatrical set inspired by street life. *The Seven Works of Mercy* would revolutionize the entire world of southern painting, becoming a primary reference point for all artists who went to train there.

The composition draws on his previous work in the *Martyrdom of Saint Matthew* for the Contarelli chapel in San Luigi dei Francesi, from which it borrows the wheel of figures placed along the radius and axes that add to the scene's dynamic sense. The light bounces off of the masses, faces, and clothes, contributing to highlighting the new synthetic sense of the volumes of Caravaggio's Neapolitan period, while the candle lit by the character in the background of the composition enhances the painting's depth and forms its fulcrum.

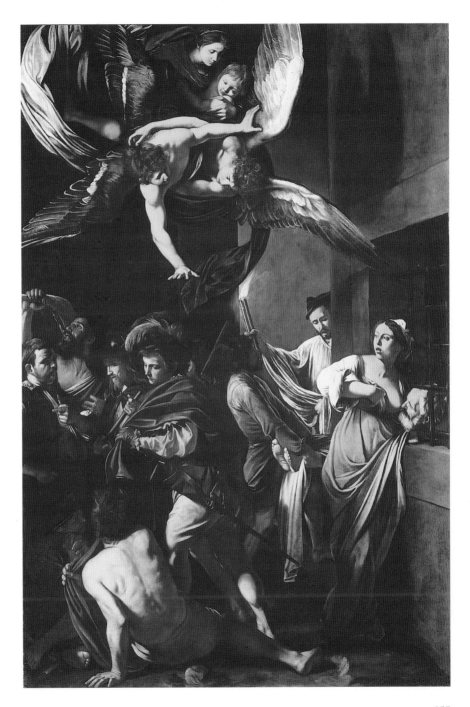

155

The Flagellation of Christ

1607–1608
Oil on canvas, 286 × 213 cm
Naples, Museo
e Gallerie Nazionali
di Capodimonte

According to Giovan Pietro Bellori, this work was painted for the chapel of the De Franchis family in the church of San Domenic Maggiore in Naples, where it is located to this day.

The *Flagellation* was the largest and most grandiose of a group of five or six works related closely to one another, which Caravaggio painted during the end of his first stay in Naples, by 1608. As in many of this period's paintings, especially those for public purposes, Caravaggio seems to choose the path of least resistance and draws inspiration, particularly for the composition, from the subject painted by Sebastiano del Piombo. The painting is organized around the column to which Christ is tied where his two torturers are arranged, one to the side and the other behind the column. Their precise and slow gestures project us into the painting's background and towards the foreground, where the third jailer is kneeling. Christ's illuminated torso seems to fluctuate in a dancing movement of mannerist inspiration, in total contrast to the fixed movements of the flagellators.

The scene was changed during the painting's execution. Radiographs show that Caravaggio had planned for another figure, under the shoulder of the jailer to the right, a perfectly finished and well-defined face that looked up towards the face of Christ. It may have been a portrait of the client, Tommaso De Franchis, which was then removed because it compromised the painting's spare quality.

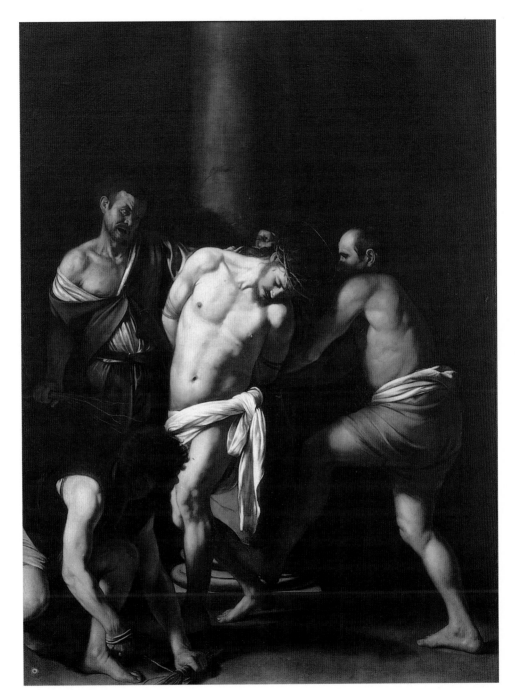

Portrait of Alof de Wignacourt

1608
Oil on canvas, 195 × 134 cm
Paris, Musée du Louvre

After Caravaggio's brief visit to Malta in 1607, he returned in the spring of the next year when began the portrait of the Grand Master of the Jerusalemite order, Alof de Wignacourt, which now hangs in the Louvre. The painting's layout, the choice of armor, the helmet, and the pose were probably suggested by the image that the Grand Master wanted to convey.

Wignacourt is depicted standing in the company of a young attendant who brings him his plumed helmet. An atmosphere of natural expectation is paired with the officialness of the Grand Master's attributes, dressed in his fighting armor, and the young boy dressed all in velvet with the cross of the knights stitched on his vest. Alof de Wignacourt is standing with his weight on one leg, with his gaze and head turned to the right and holding a club in his hand, while his attendant directs his gaze at us. The almost informal naturalness of this portrait of the Grand Master brings us back to Caravaggio's Lombard training, specifically to similar subjects of the sixteenth century Brescian tradition with which Caravaggio was quite familiar.

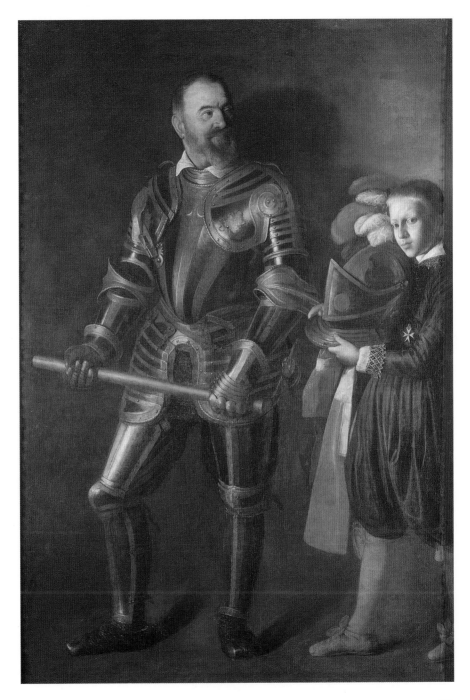

Portrait of a Knight of Malta, Fra Antonio Martelli

1608–1609
Oil on canvas, 118.5 × 95 cm
Florence, Palazzo Pitti

Antonio Martelli was about seventy years old and had been a knight of the order of Saint John of Jerusalem since he was approximately twenty years old. He had been the high military administrator in Tuscany for Ferdinando I de' Medici, admiral of the fleet, and prior of Hungary. Around March of 1608, he was assigned to the priorship of Messina and therefore left Malta. We do not know with certainty if the painting was made in Malta before Martelli left for Syracuse, or if it was painted in Messina after Caravaggio escaped Malta. The latter case would leave unsolved another of the many mysteries that surround Caravaggio's life: why would Martelli have himself portrayed by a painter who had just been run out of the order of knights of Malta as a *putridum et foetidum*, unwanted member? Is he the man who organized Caravaggio's escape to Sicily?

Unlike the full portrait of the Grand Master of the Order, Antonio Martelli is portrayed to just below his belt. The view is so close up and unsparing that all of the elderly knight's wrinkles are visible. However, the figure he cuts is far from that of an old man who has laid down his arms, and is marked by the light that highlights his still sturdy chest and his arm at the ready on his sword.

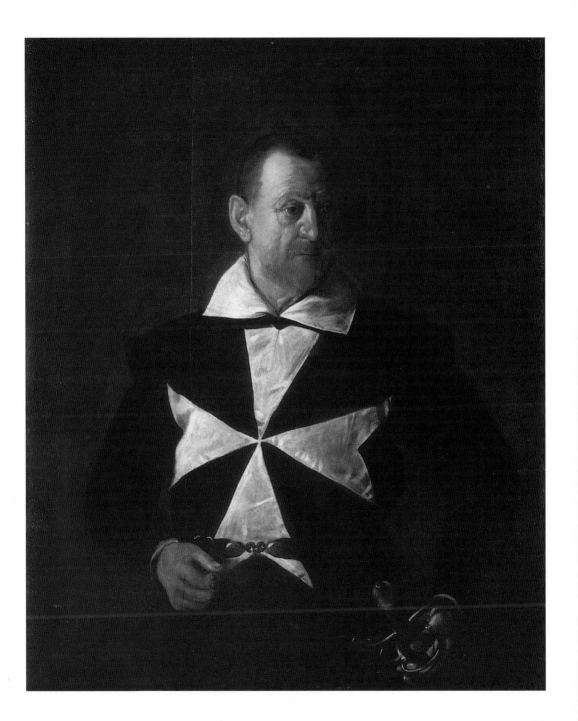

The Beheading of Saint John the Baptist

1608
Oil on canvas, 361 × 520 cm
La Valletta (Malta), oratory of
Saint John the Baptist of the
order of knights

It is uncertain whether it was Fabrizio Sforza Colonna to commission Caravaggio for *The Beheading of Saint John the Baptist* for the new oratory of the knights of Malta. However, the large *Beheading* brought to Caravaggio "besides honoring him with the cross [...] a precious golden chain and made him a gift of two slaves among other things as a sign of his esteem and satisfaction with his work," and on July 14, 1608, he was made knight.

The painting covers the entire portion of the wall on which it hangs so that the scene appears illusionistically to actually take place inside the chapel. The violence has been done, the neck is bleeding, and in the blood is written the only signature that Caravaggio ever left on a painting. Saint John is stretched on the ground and the four figures—the executioner and three onlookers—are positioned with a precise, symmetrical compositional rhythm. The bending executioner is mirrored by the woman who is bending over a tray and behind them the two onlookers are both standing, each isolated in a personal gesture and expression. The scene is framed to the side by what appears to be a random street of the era, shadowed and in contrast with the stream of light that highlights the act of martyrdom.

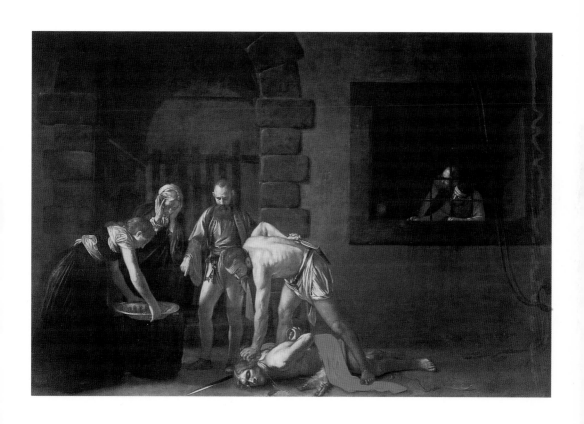

163

The Burial of Saint Lucy

1608–1609
Oil on canvas, 408 × 300 cm
Syracuse, Museo Nazionale
di Palazzo Bellomo

In the second half of 1608, Caravaggio went from Malta to Syracuse, where his old friend from his early Roman days, Mario Minniti, awaited him, having established himself as a painter in the local scene in the meantime. The fact that the senate of Syracuse quickly commissioned him for an important altarpiece portraying Saint Lucy, the city's patron saint, to place on the altar of the church dedicated to her, is another mystery given Caravaggio's status as a fugitive. At any rate, Caravaggio quickly completed *The Burial of Saint Lucy* for the Syracusans and then moved to Messina, where he stayed for several months, completing new public and private commissions.

The painting's vertical format emphasizes the empty space, and slight architectural reference of the background, which is an essential part of the sense of dramatic tragedy of the scene opened by the two gravediggers standing with wide legs in the foreground. Behind them is the saint, stretched on the ground on her back. She is surrounded by a group of worshippers in procession whose dimensional apex is the blessing bishop. The contrasted light cleanly shows the volumes and spreads in the empty space of the background. The years in which Caravaggio painted *The Burial of Saint Lucy* represented a new phase in Caravaggio's art, a genre that was sparer, more rapid and with a smaller scale for the figures. These elements fit well with the use of red priming as a base color and the figures emerging from very dark backgrounds and shadows with long touches of light in a proportional relationship between the figures and the spaces that was entirely new, almost of a classical nature, which framed scenes with several figures, in large and bare spaces, that were architecturally only hinted at with the variation of dark tones.

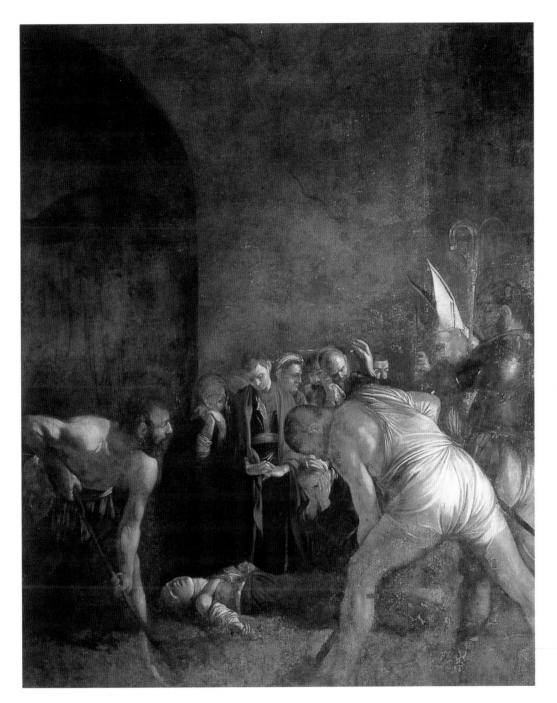

The Raising of Lazarus

1609
Oil on canvas, 380 × 275 cm
Messina, Museo Regionale
di Messina

As soon as Caravaggio arrived in Messina, he received a major commission for which he was paid the exorbitant sum of a thousand scudi. The work had been ordered by a Genovese businessman living in Messina named Lazzari who was delighted to accept Caravaggio's suggestion to portray *The Raising of Lazarus* for the altar of the chapel that he had recently bought.

Caravaggio constructed the scene like a classic frieze; all of the participants of the event are on a single plane; Christ with His finger pointed, Lazarus collapsed on the diagonal, the distraught sisters, and behind them, the crowd of witnesses to the miracle. An empty, dark space gravitates around the event, all the more looming because varied by shadow. The light, directed from the left, highlights Christ's profile and fully hits the emaciated nude body of Lazarus in the center of the scene. The spare painting of the bystanders is contrasted with the thoroughness with which the gaunt nude is shown in which his soft flesh and bony contours can be discerned. The clothes painted with long, simple brushstrokes seem inspired by examples of classical sculpture, as does the entire composition.

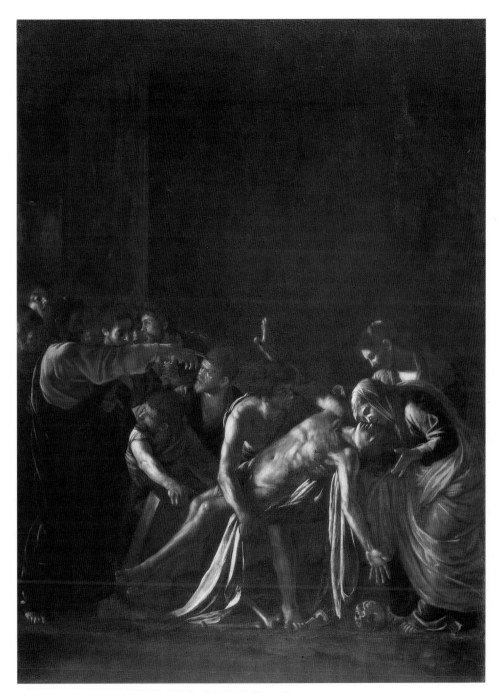

167

The Denial of Saint Peter

1609–1610
Oil on canvas, 94 × 125.5 cm
New York, The Metropolitan
Museum of Art

This painting was likely made during the last year of Caravaggio's life when he came to Sicily after fleeing Malta, where he had been imprisoned shortly after receiving the investiture of knight in the order of Saint John. He stayed in Sicily for a short time before returning to Naples.

This *Denial of Saint Peter* dates from this second Neapolitan stay. Its execution is more abbreviated, its genre is sparer and it sees the emergence of the use of reddish base and the enrichment of the dark colors with long touches of light. In *Denial of Saint Peter* it is light that strikes the three quarter figure of the saint, emphasizing his gesture and expression, while leaving the face of the woman partly in shadow; and it is light that gleams off of the metal vest of the soldier depicted in profile.

The close-up view of the three figures focuses attention on the dialogue of expressions and gestures that connects them in a close, mute conversation, linking these religious themes of his last works with his early experiments in the emotional relationships of figures, though in a less dramatic and powerful execution.

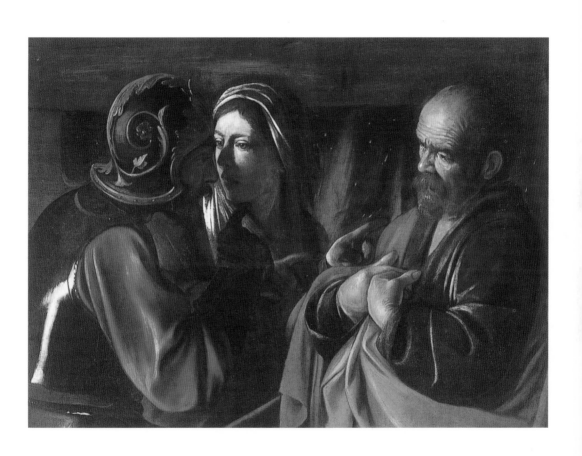

The Martyrdom of Saint Ursula

1609–1610
Oil on canvas,
140.5 × 170.5 cm
Banca Intesa Collection

This work, which is currently under restoration, is among the last of Caravaggio's paintings. It was likely painted in the last year of his life in Naples where it was then sent to Marcantonio Doria in Genoa.

The four figures emerge from a burnished background, which is perceptible only through the subtle variation of tone, constructed by long touches of light and color. The saint, summarized with volumes that prefigure modern art, emerges from the variation of her white flesh in the light, emphasizing the pose which is made all the more dramatic by her almost lucid acceptance of martyrdom that can be understood by her gesture, her hands clasped over her wound and her head lowered to look without any movement of pain or desperation. The saint and her executioner are the only two figures to be highlighted with red, in a wide spectrum that ranges from white to dark brown, dark ochre and black. The soldier, on level with the saint, is captured with his mouth open after having struck the blow. His head, constructed with short tonal touches, anticipates Rembrandt's achievements.

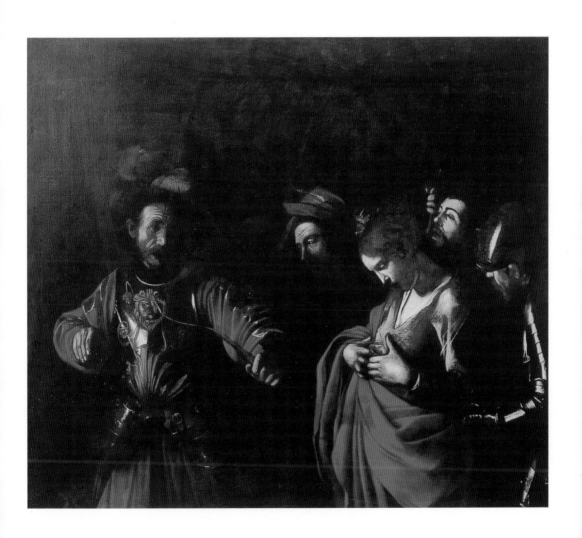

Appendix

The Fortune Teller
(detail), 1593–1594
Rome, Pinacoteca Capitolina

Chronological Table

	The Life of Caravaggio	Historical and Artistic Events
1571	Michelangelo Merisi is born in Milan to Fermo and Lucia Aratori on September 29, Saint Michael the Archangel's Day.	Victory of the Christian fleet over Turks at Lepanto.
1572		Saint Bartholomew's night massacre of Huguenots in France.
1577	During the plague his father and a brother die. The family moves to Caravaggio.	
1584	Caravaggio begins his apprenticeship in Milan with the painter Simone Peterzano.	Charles Borromeo, archbishop of Milan dies.
1585		Beginning of Sixtus V's papacy, until 1590.
1587		Mary Stuart sentenced to death.
1588	His stay with Simone Peterzano ends.	Destruction of the Invincible Armada: English victory over Spain.
1590	Caravaggio's mother dies.	
1592–1593	Twenty-one-year-old Caravaggio moves to Rome.	Beginning of Clement VII's papacy, until 1605.
1593	He recovers from an illness at the Spedale della Consolazione. Shortly thereafter, he becomes part of Cavalier d'Arpino's workshop for a few months.	Henry IV, King of France, renounces Calvinism for Catholicism.
1595		Federico Borromeo is elected Archbishop of Milan and assumes the seat, but conflict with the Spanish government forces him to return to Rome (1597).
1595–1596	He is taken into the household of his protector, Cardinal Francesco Maria Del Monte, ambassador of the Grand Duke of Tuscany in Rome.	
1598		Peace of Vervins between Spain and France: Henry IV issues the edict of Nantes granting freedom of religion to the Huguenots. Phillip II of Spain dies.

	The Life of Caravaggio	Historical and Artistic Events
1599	Caravaggio receives his first public commission: the histories of Saint Matthew in San Luigi dei Francesi.	
1600	He receives a commission for two paintings for the Cerasi chapel in Santa Maria del Popolo.	Holy celebrations for the jubilee year. Giordano Bruno is burned at the stake in Rome. Henry IV of France marries Maria de' Medici.
1603	A trial is brought against Caravaggio and some of his artist friends for slander against painter Giovanni Baglione.	James I begins the Stuart dynasty. The Accademia dei Lincei is founded in Rome.
1604–1605	Caravaggio is arrested for slander and bearing illegal arms.	
1605	He takes refuge in Genoa with Marcantonio Doria.	After the brief papacy of Leo XI, Paul V is elected pope.
1605–1606		Shakespeare writes *King Lear* and *Macbeth*.
1606	The *Madonna dei Palafrenieri* is removed from Saint Peter's; *The Death of the Virgin* is rejected. Caravaggio kills Ranuccio da Terni in a brawl; he flees to the Colonna estates (Zagarolo and Paliano), and then to Naples.	Pope Paul V places an interdict on the Republic of Venice.
1607–1608	Stay in Malta: he paints the enormous *Beheading of Saint John the Baptist*; he is named knight of the order of Malta. Escapes to Syracuse.	
1609	Continues his flight, going to Messina, Palermo and Naples: in Naples he is attacked and wounded on his face.	Johannes Kepler publishes the *New Astronomy*.
1610	Having received a pardon from the Pope, Caravaggio dies on July 18 at Port Ercole, a stop on his return to Rome.	Henry IV is assassinated; reign of Maria de' Medici on the throne of France. Charles Borromeo is proclaimed a saint.

Geographical Locations of the Paintings
in public collections

Italy

Saint Francis in Prayer
Oil on canvas, 130 x 90 cm
Cremona, Pinacoteca
del Museo Civico
1605–1606

Bacchus
Oil on canvas, 95 x 85 cm
Florence, Galleria degli Uffizi
1596–1597

Medusa
Oil on canvas on convex
shield, 60 x 55 cm
Florence, Galleria degli Uffizi
1598

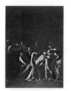

The Sacrifice of Isaac
Oil on canvas, 104 x 135 cm
Florence, Galleria degli Uffizi
1603–1604

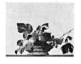

*Portrait of a Knight of Malta,
Fra Antonio Martelli*
Oil on canvas, 118.5 x 95 cm
Florence, Palazzo Pitti
1608–1609

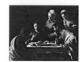

The Raising of Lazarus
Oil on canvas, 380 x 275 cm
Messina, Museo Regionale
di Messina
1609

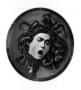

*Sill Life with a Basket
of Fruit*
Oil on canvas, 31 x 47 cm
Milan, Pinacoteca
Ambrosiana
1597–1598

Supper at Emmaus
Oil on canvas, 141 x 175 cm
Milan, Pinacoteca di Brera
1606

Seven Works of Mercy
Oil on canvas, 390 x 260 cm
Naples, Pio Monte della
Misericordia
1607

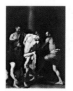

The Flagellation of Christ
Oil on canvas, 286 x 213 cm
Naples, Museo
e Gallerie Nazionali
di Capodimonte
1607–1608

Italy

The Martyrdom
of Saint Ursula
Oil on canvas,
140.5 x 170.5 cm
Banca Intesa Collection
1609–1610

Boy with a Basket of Fruit
Oil on canvas, 70 x 67 cm
Rome, Galleria Borghese
1593–1594

Self-Portrait as Sick
Bacchus
Oil on canvas, 67 x 53 cm
Rome, Galleria Borghese
1593–1594

The Fortune Teller
Oil on canvas, 115 x 150 cm
Rome, Pinacoteca
Capitolina
1593–1594

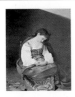

Penitent Magdalen
Oil on canvas,
122.5 x 98.5 cm
Rome, Galleria Doria
Pamphilij
1594–1595

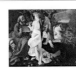

The Rest on the
Flight into Egypt
Oil on canvas,
135.5 x 166.5 cm
Rome, Galleria Doria
Pamphilij
1595–1596

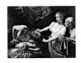

Judith Beheading Holofernes
Oil on canvas, 145 x 195 cm
Rome, Galleria Nazionale
d'Arte Antica,
Palazzo Barberini
1599

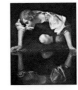

Narcissus
Oil on canvas, 112 x 92 cm
Rome, Galleria Nazionale
d'Arte Antica,
Palazzo Corsini
1599

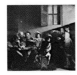

The Calling of
Saint Matthew
Oil on canvas, 322 x 340 cm
Rome, San Luigi
dei Francesi,
Contarelli chapel
1599–1600

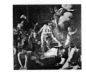

The Martyrdom of Saint
Matthew
Oil on canvas, 323 x 343 cm
Rome, San Luigi
dei Francesi,
Contarelli chapel
1600–1601

Italy

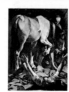

The Conversion
of Saint Paul
Oil on canvas, 230 x 175 cm
Rome, Santa Maria
del Popolo, Cerasi chapel
1600–1601

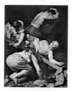

The Crucifixion
of Saint Peter
Oil on canvas, 230 x 175 cm
Rome, Santa Maria
del Popolo, Cerasi chapel
1600–1601

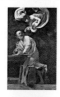

The Calling of
Saint Matthew
Oil on canvas, 295 x 195 cm
Rome, San Luigi
dei Francesi,
Contarelli chapel
1602

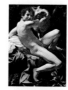

Saint John the Baptist
Oil on canvas, 132 x 97 cm
Rome, Pinacoteca
Capitolina
1602

Madonna of Loreto
Oil on canvas, 260 x 150 cm
Rome, Sant'Agostino,
Cavalletti chapel
1604–1606

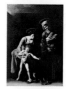

Madonna of the Palafrenieri
Oil on canvas, 292 x 211 cm
Rome, Galleria Borghese
1605–1606

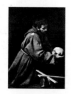

Saint Francis in Meditation
Oil on canvas, 128 x 97 cm
Rome, chiesa
dei Cappuccini
1605

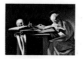

Saint Jerome
Oil on canvas, 112 x 157 cm
Rome, Galleria Borghese
1605–1606

David with the Head
of Goliath
Oil on canvas, 125 x 100 cm
Rome, Galleria Borghese
1605–1606

The Burial
of Saint Lucy
Oil on canvas, 408 x 300 cm
Syracuse, Museo Nazionale
di Palazzo Bellomo
1608–1609

Austria

The Crowning with Thorns
Oil on canvas, 127 x 165 cm
Vienna, Kunsthistorisches
Museum
1603

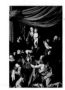

Madonna of the Rosary
Oil on canvas, 364 x 249 cm
Vienna, Kunsthistorisches
Museum
1607

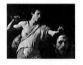

*David with the Head
of Goliath*
Oil on panel,
90.5 x 116.5 cm
Vienna, Kunsthistorisches
Museum
1607

Vatican City

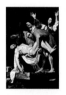

Deposition
Oil on canvas, 300 x 203 cm
Vatican City,
Pinacoteca Vaticana
1602–1604

France

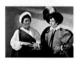

The Fortune Teller
Oil on canvas, 99 x 131 cm
Paris, Musée du Louvre
1596–1597

Death of the Virgin
Oil on canvas, 369 x 245 cm
Paris, Musée du Louvre
1604

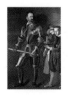

*Portrait of Alof
de Wignacourt*
Oil on canvas, 195 x 134 cm
Paris, Musée du Louvre
1608

Germany		*Cupid* Oil on canvas, 156 x 113 cm Berlin-Dahlem, Gemäldegalerie, Staatliche Museen, Preussischer Kulturbesitz 1602–1603	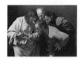	*The Incredulity* *of Saint Thomas* Oil on canvas, 107 x 146 cm Potsdam-Sanssouci, Stiftung Schlösser und Gärten 1600–1601
Great Britain	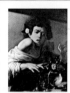	*Boy Bit by a Lizard* Oil on canvas, 66 x 49.5 cm London, National Gallery 1595–1596	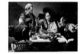	*Supper at Emmaus* Oil on canvas, 141 x 196.2 cm London, National Gallery 1601
Ireland	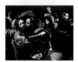	*The Betrayal of Christ* Oil on canvas, cm133.5 x 169.5 Dublin, Society of Jesuits of Saint Ignatius, on loan to the National Gallery of Ireland, 1602		
Malta		*The Beheading of* *Saint John the Baptist* Oil on canvas, 361 x 520 cm La Valletta (Malta), oratory of Saint John the Baptist of the order of knights 1608		
Russia		*The Lute Player* Oil on canvas, 94 x 119 cm St. Petersburg, The State Hermitage Museum, 1595–1596		

Spain

*Saint Catherine
of Alexandria*
Oil on canvas, 173 x 133 cm
Madrid, Museo Thyssen-
Bornemisza
1597

David and Goliath
Oil on canvas, 116 x 91cm
Madrid, Museo Nacional
del Prado
1597–1598

USA

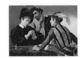

The Cardsharps
Oil on canvas, 94.2x 130.9
cm
Fort Worth, Kimbell Art
Museum
1594

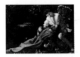

Saint Francis in Ecstasy
Oil on canvas, 92.5 x 128.4 cm
Hartford, Wadsworth
Atheneum, The Ella Gallup
Sumner and Mary Caitlin
Sumner Collection Fund
1594–1595

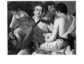

The Musicians
Oil on canvas,
87.9 x 115.9 cm
New York, The Metropolitan
Museum of Art, Roger Fund
1595

The Denial of Saint Peter
Oil on canvas, 94 x 125.5 cm
New York, The Metropolitan
Museum of Art
1609–1610

Writings

The modern naturalism, in a restricted sense, begins in the harshest way with *Michelangelo Amerighi da Caravaggio* (1562–1609), who exercised a great influence on Rome and Naples. It is his delight to prove to the beholder that all the sacred events of old time happened just as prosaically as in the streets of the southern towns towards the end of the sixteenth century; he cares for nothing but passion, and has a great talent for expressing this in a truly volcanic manner. And this passion expressed only in vulgar energetic characters, sometimes most striking, forms the fundamental tone of his own school (*Valentin, Simon Vouet,* also their follower, *Carlo Saraceni* of Venice), and also of the school of Naples. Here the Valencian *Giuseppe Ribera*, called *lo Spagnoletto* (born 1593, disappeared 1656), is the follower, intellectually, of Caravaggio in the smallest sense of the word, although his colouring, as is the case with his master in still a higher degree, his earlier study of Correggio and the Venetians is distinctly felt. With him worked, as well as the painter called *Corenzio, Giovanni Battista Caracciolo*, who attached himself more to the style of the Carracci; his great pupil, *Massimo Stanzioni* (1585-1636), also adopted as much from Ribera as was consistent with his own tendency. (His most remarkable pupil: *Domenico Finoglia*.)

Indirectly followers of Caravaggio among the Neapolitans: *Mattia Preti*, called *il Cavalier Calabrese* (1613–1690), *Andrea Vaccaro*, and others.

With Caravaggio and the Neapolitans drawing and modeling are altogether considerably inferior, as they think they may rely on quite another means for effect. Commonplace as their forms are besides, one cannot the more depend that in special cases they are really taken from life; in their vulgarity they are only too often vague as well. In this school there are, on the whole, but few conscientious pictures.

Among the naturalists, the earliest, *Caravaggio*, from whom also Guercino learned indirectly, is certainly one of the best colourists. The strong cellar light, in which he and many of his followers love to place their scenes, indeed excludes the endless richness of beautiful local tones, which can only be conceived with the as-

sistance of clear daylight; it is characteristic, besides this, that the naturalists, in spite of all their preference for inclosed light, should so little enter into the poetry of Chiaroscuro. [1]

Caravaggio's histories of St. Matthew in S. Luigi de' Francesi at Rome (last chapel on the left) are indeed so placed that one can hardly judge the effect of colour, though this may have grown very much darker; but it is certain (also from his other works) that he intentionally aimed at the impression of harshness and gloom, and that the absence of reflections is an essential means for this.

[1] Still we must recall his youthful works, which, in their clear, harmonious tone, principally golden yellow, betray the study of the Venetians (Giorgione), as the famous picture, the Gamesters, in the P. Sciarra; a Judith with the Maid, formerly in the Scarpa collection at La Motta near Treviso, now in England; also the splendid Woman playing on the lute in the Lichtenstein Palace in Vienna. Here too belongs, though a little later perhaps, the Conversion of Paul in figures of life size, in the Palace Balbi–Piovera at Genoa—a remarkable instance of his careful choice of a noble and ideal subject, which he afterwards drags down, *con amore*, into triviality and commonplace. But in painting it is a masterpiece, the *chiaroscuro* has the true artistic feeling, and is captivating in its charm—the shadows quite transparent, the drawing sharp, the execution most careful and irresistibly beautiful.

*E*xtracts from Howard Hibbard's Caravaggio. *Copyright © 1986 by Howard Hibbard. Reprinted by permission of Westview Press, a member of Perseus Books, L.L.C.*

Caravaggio is the most arresting European painter of the years around 1600. Although he died in 1610, in his thirty-ninth year, he is often considered the most important Italian painter of the entire seventeenth century. He is also notorious as a painter-assassin: he killed a man in 1606, and a similar crime was rumored in his youth. We would not be fascinated by his personality and his crimes had he not been a great painter; but the extent and even the nature of his artistic contribution is still in question,

and his paintings will always be controversial. For contemporaries like Giulio Mancini, Caravaggio was famous as a realistic genre painter, his best picture the *Gypsy Fortuneteller*. More recently, especially since Walter Friedlaender's *Caravaggio Studies* of 1955, he has been hailed as an original and personal interpreter of scripture. An Italian writer has recently compared his achievement to that of Giotto and Masaccio; another actually likened his exploration of nature to Galileo's.

Caravaggio's paintings speak to us more personally and more poignantly than any others of the time. We meet him over the gulf of centuries, not as a commanding and admirable historical figure like Annibale Carracci, but as an artist who somehow cut through the artistic conventions of his time right down to the universal blood and bone of life. Looking back almost four hundred years, we see him as the first Western artist to express a number of attitudes that we identify, for better or for worse, as our own. Ambivalent sexuality, violent death, and blind faith in divine salvation are some of the contradictory messages and images that pervade his works. If one were to try to reduce Caravaggio's contribution to the history of art to a single sentence, it might be said that he was the only Italian painter of his time to rely more on his own feelings than on artistic tradition, while somehow managing to remain within the great mainstream of the Renaissance. From this point of view he is an important precursor of Rembrandt and even of modern art.

MILAN

Michelangelo Merisi, described as living in Milan, was apprenticed on 6 April 1584, aged about twelve and a half, to the Milanese painter Simone Peterzano, who was then living in the parish of San Giorgio al Pozzo Bianco. The notarial document stipulated four years' service in Peterzano's home and shop together with payment by Caravaggio of 24 gold *scudi*.[1]

Milan at this time was nominally ruled by Philip II of Spain through a governor, but it was dominated by the spirit of Archbishop Charles Borromeo (1538–1584). He had been a force in the

last session of the Council of Trent and was canonized in 1610, the first in a great succession of Counter Reformation saints that included Ignatius Loyola and Teresa of Avila. Charles was the first resident archbishop in a century, which points up the decay of the Italian Renaissance Church. He literally wore himself out trying to repair the damage and threatened to excommunicate the Spanish rulers when they interfered, citing the example of his great Early Christian predecessor, St. Ambrose. By example and reform, Charles harried Milan into the Catholic Reformation era almost in spite of himself. Perhaps some splinter of his zealous spirit embedded itself in Caravaggio.[2]

Caravaggio's master, Simone Peterzano, worked chiefly in Milan from 1573 until 1596. He came from nearby Bergamo, which was Venetian territory, and had evidently studied with the aged Titian in Venice since he signed one painting "student of Titian". Venetian art was so clearly dominant in north Italy during the Cinquecento that most Lombard painters were at least touched by its light and color, its fluid and sometimes dynamic rendering of forms in space, its lyrical themes. One of Titian's greatest altarpieces, a *Christ Encrowned with Thorns*, was in a Milanese church, but its presence did not suffice to inspire the local school. By the end of the century there must have been a strong sense even in Venice that the golden age was over; talented artists like Palma il Giovane (circa 1548–1628) failed to approach the incandescence of their masters. The single exception was El Greco (1541–1614), who had moved from Crete to Venice to Rome and finally to Spain in 1577. His art, essentially unknown to Italians, was predicated on the achievement of Venice and particularly that of Tintoretto. Perhaps Peterzano was in Titian's studio together with El Greco in the 1560s.

By comparison with Titian, Tintoretto, and Veronese, Milanese painters were rigidly academic. Giovan Paolo Lomazzo (1538–1600), the chief theoretician of Milanese art, went blind early in his career; his successors were mediocrities like Peterzano. Despite his Venetian training, Peterzano's art is thoroughly Lombard, with weighty classicizing forms, hard outlines, and realistic details only occasionally enlivened by a flicker of Titianesque color and atmosphere. A stronger, more popular art was practiced by members of the Campi family from Cremona, and some of them were painting in Milan in Caravaggio's time. Perhaps as a consequence, the next generation of Lombard painters was more vigorous than its counterpart in Venice although only Caravaggio attained international stature.[3]

No paintings from Caravaggio's Lombard years have been identified. Since north-Italian reminiscences crop up in his later pictures, it will be more useful to discuss these memories when they are appropriate than try to recreate what Caravaggio may have seen and remembered from his earlier years. Surely he knew works by all the local masters, past and present, not only of Milan but of nearby Lodi and Cremona. Brescia and Bergamo, not far away, had strong local schools of painting that were frequently renewed by contact with Venice. Savoldo, Romanino, and Moretto in Brescia were probably direct influences on Caravaggio's art. There were also a variety of Giorgionesque painters active in Lombardy whose works Caravaggio would have known, such as Giovanni Carini, who worked in Bergamo, and Bartolomeo Veneto, who spent his last years in Milan. Lorenzo Lotto (died 1556) painted poetic visions during a long stay in Bergamo, where G. B. Moroni (died 1578), Moretto's pupil, carried on a literal version of his teacher's style that can still be identified in an early portrait by Caravaggio.

Caravaggio should have learned from Peterzano the fundamentals of painting, the grinding of colors, the preparation of walls for fresco, and the basic principals of drawing and applying paint to wall and canvas. He learned those things, that is, if he actually completed his apprenticeship. In view of his later resistance to authority, his impatience and unusual belligerence, we may wonder. Moreover, there are fundamental aspects of Renaissance painting, mastered by Peterzano, that Caravaggio did not learn or refused to practice. He never painted frescoes. He was presumably not much of a draftsman since not one drawing has sur-

vived. His ability to paint figures in a believably receding space was deficient. Peterzano's name is absent from Milanese documents during 1586–1589; part of that time he may have spent in Rome. If he did not take the young Caravaggio along, his education may have been interrupted or terminated in ways that we do not know. Nevertheless, Giulio Mancini, our earliest Roman source of information, was of the opinion that Caravaggio had served a normal apprenticeship.

There was a rumor, much later, that Caravaggio killed someone and had to flee Milan— Giovan Pietro Bellori, a reliable Roman scholar, scratched this in the margin of Giovanni Baglione's *Lives of the Painters*. The story may have come from Mancini, who heard that Caravaggio had committed a crime and spent a year in a Milanese jail.[4] True or not, it must have sounded probable in the light of his later escapades. Perhaps, however, Caravaggio's character was not wholly unusual. The painter and theoretician G. B. Armenini remembered a visit to Milan, perhaps in the late 1550s, when he "took up with some young Milanese whom I found much more dedicated to adorning themselves with clothes [Milan was the home of millinery] and fine shining arms than to handling pens or brushes"—which at least in part describes the Caravaggio we know in Rome.[5]

The enigma of Caravaggio and his art will remain forever, but we are coming closer to understanding him for our time and to seeing him more accurately in his own. He was far from being a universal artist, but however flawed and peculiar his paintings may be, they are the most fascinating of their era. From ambiguous essays in erotic, retrospective pseudo-genre he moved to grand displays of traditional Mediterranean figural art. Yet these religious pictures are also the most personal and affecting works by any artist between Michelangelo and Rembrandt. At his best, Caravaggio is an artist for everyone and for all time.

[1] This and all other documents known c. 1970 are printed in Cinotti (1971, pp. 146 ff.), sometimes with new transcriptions. Summaries in Cinotti (1973), with newly discovered material about Caravaggio's birth, and a few errors,

corrected and amplified by Cinotti (1975). Marini (1974) also prints the documents.

[2] See Gregori (1973, pp. 19 ff.) and, in general, *Storia di Milano* (1957). For St. Charles, see M. de Certeau in *Dizionario biografico degli italiani* (XX, 1977, pp. 260 ff.). The Counter Reformation is surveyed by O'Connell (1974), which lacks theological discussions; see the *Enciclopedia cattolica* and the *New Catholic Encyclopedia*. Evennett (1970) is the best short introduction. Cf. Cochrane (1970) for essays on the general period.

[3] For Lombard painting, see Dell'Acqua (1957); Ciardi (1968, pp. 23–31); Freedberg (1975); Begni Redona (1963); Bossaglia (1964); and Zampetti (1975). Peterzano is discussed by Baccheschi (1978).

[4] Mancini wrote that Caravaggio was apprenticed in Milan and worked diligently, "although now and again he would do some outrageous thing" (p. 223; see Appendix II, p. 346). In a later note filled with a confusing jumble of ideas, Mancini says that he committed a crime, wounded a police agent, and was thrown into a Milanese jail for a year (p. 227, n.). Bellorin, in a marginal note to his copy of Baglione's *Lives*, wrote that Caravaggio killed a companion and had to flee the territory (margin, p. 136; see p. 351 below). Baglione himself seems to have known none of this; when Bellori came to write his life of Caravaggio he merely said that after he had painted portraits for some time, being quarrelsome and contentious, he got into trouble and fled Milan for Venice. No records of these Milanese difficulties have yet been found (Cinotti, 1975, pp. 211–212).

[5] Armenini (1977, p. 290). For Mancini, Baglione, and Bellori, see Appendix II, pp. 346, 351, 360.

FRANCESCO SCANNELLI

Francesco Scannelli, *Il microcosmo della pittura...* (Cesena, 1657). Scannelli, like Mancini, was a medical doctor and an amateur of painting. His home was in Forlì in the Romagna, and his point of view was influenced by the nearby school of Bologna. The book tries to discuss painters in order of merit, beginning with Raphael, and it divides Italian painting into four schools: the Roman school of Raphael, the Venetian of Titian, the Lombard of Correggio, and the Bolognese of the Carracci.

[Book I, Chapter VIII] And since the true and ultimate scope of the good painter is the imitation of natural forms, and an estimable painting being in fact nothing other than an already well-conceived expression put forward with full cognizance of the

best elements of nature, consequently it follows that he who invigorates color with the most excellent artifice, bringing forth his longed-for objective, ought to gather the fruit of greater fame, just as Michelangelo da Caravaggio did when he appeared on the world's stage. He was a unique exponent of naturalism, nurtured by his own instinct to paint from nature, and in this fashion rising from imitations of flowers and fruits, from less perfect figures to the most sublime, from irrational to more human portraits, and finally by painting complete figures, and sometimes also narratives, with such truth, vigor, and relief quite often nature, if not actually equaled and conquered, would nevertheless bring confusion to the viewer through his astonishing deceptions, which attracted and ravished human sight; and so he was regarded by many as being most excellent above all others.

But one must speak calmly about this particular style, because from imperfect premises one can deduce only false conclusions. And if, in fact, such an artist did not demonstrate that he was endowed with a particular talent, he gave his works an extraordinary and truly singular imitation of nature, and an injection of force and relief greater perhaps than any other. Nevertheless he lacked the necessary basis for good design, producing faulty creations without completely achieving a beautiful conception, gracefulness, decorum, architecture, perspective, or other similar and significant elements that together render sufficiently worthy the truce principles of the greatest masters. And he, almost totally without these qualities, and in comparison to the above-mentioned first masters of painting, must appear inferior and imperfect.

FRANCESCO SUSINNO

Francesco Susinno, *Le vite de' pittori messinesi.* Manuscript dated 1724. First published by Valentino Martinelli (Florence, 1960). Susinno was called "Susino" by early writers; his opinions were known through extracts and versions of his manuscript and were the basis of Filippo Hackert's *Memorie de' pittori messinesi* (Naples, 1792). Susinno, who called himself *"pittore"* on the title page of his manuscript,

was a priest who had studied in Rome and had studied painting in Naples. His *Lives* are unique for their local lore, and for that reason his stories about Caravaggio and Caravaggio's friend Mario Minnitti of Syracuse are of interest, if not necessarily reliable.

...he then went to Malta. On that island Caravaggio was warmly welcomed by the Grand Master Wignacourt, a French nobleman, because the skills of Caravaggio's brush were greatly appreciated and his works highly desired. His Eminence did not delay in commissioning the Martyrdom of St. John, a work of art of immense value for which the Grand Master honored him with a gold necklace, two slaves, and other rewards worthy of the magnanimity of this gentleman. Caravaggio painted the portrait of the Grand Master standing in armor and another of the same gentleman dressed in ceremonial garments. For these two works Caravaggio was named *Cavaliere dell'abito.*

Michelangelo with the cross on his chest did not abandon his natural belligerence but let himself be blinded by the madness of thinking himself to be a nobleman born. The mark of knighthood is not manifested by presumptuous action; the knight must render himself commendable by pleasantness. Nevertheless he became so daring that one day he had the courage to compete with some other swordsmen and to affront the Cavaliere of Justice. Wignacourt was forced to imprison him in a castle. But one night Caravaggio scaled the wall and fled to Sicily, arriving in the city of Syracuse, where he was welcomed by his friend and colleague in the study of painting, Mario Minnitti, a painter from Syracuse, from whom he received all the kindness that such a gentleman could extend to him. Minnitti himself implored the Senate of that city to employ Caravaggio in some way so that he could have the chance to enjoy his friend for some time and be able to evaluate the greatness of Michelangelo, for he has heard that people considered him to be the best painter in Italy.

Through its authority, the Senate gave Caravaggio the commission for a large canvas of the virgin and martyr St. Lucy of Sicily. Today one

can still admire this painting, which was dedicated to that glorious saint in the Franciscan church outside the walls of the city of Syracuse. In this large canvas the painter depicted the dead body of the martyr stretched out on the ground while the bishop and the people come to bury her, and two handymen with shovels, who are the largest figures in this work, one on one side and the other on the other, dig a grave in which the body lay to rest.

This big canvas came out so well that it became famous; the idea behind it was so good that there are many copies in Messina and in other cities of the Regno.

Extracts from Roberto Longhi's Three Studies., *reprinted by permission of Stanley Moss/Sheep Meadow Press.*

CARAVAGGIO

The deep coherence between inner and outer worlds in the visual arts gives Savoldo's pastoral motifs their formal integrity, a certain country-bred sincerity and directness that sets them as far apart from the wistful bucolics of the school of Giorgione as it brings them close to the spirit of early Caravaggio. Or, more specifically, the spirit of Savoldo's holy encounters, the rustic vigor of his Treviso angel, his shepherds, his Tobiases, pass into the younger painter's comely angels, beguiling musicians, and Narcissus figures; just as the hermits, apostles, confessors, and saints of Savoldo's manger scene turn up at analogous points in the works of Caravaggio's maturity.

A new notion of action is inaugurated here: a new way of worshipping, marveling, emoting: a surfacing of eager gestures that pierce the canvas deeply, pressing form into new foreshortenings whose "tonal hieroglyphics" eliminate the role of *disegno*. The clarity with which these innovations are achieved often makes them look like nothing so much as the product of great acuteness of observation, bordering perhaps on a certain lack of imaginative vision. It is, in fact, a quality so long misconstrued as "dryness" or "effortfulness" in the young Caravaggio

that, even until recently, his draughtsmanship was likened to Bronzino's or Pulzone's: a historical appraisal so radically off the mark as to risk muddling the whole question of his historical significance and, as a consequence, that of all painting for the several centuries following.

To stress the connection between these two painters in another way: the surest moral precedent for Caravaggio's grand inspiration for the [Vatican] entombment, which sorrowfully portrays Christ as a man murdered by fellow men, is to be found in Savoldo's poignantly human masterpiece on the same theme in the Lichtenstein Collection. The austere, earthbound conclusion Caravaggio's work will reach is adumbrated by Savoldo with a true-to-life concreteness. The swarthy man's deathly pallor; the garments dangling against naked flesh, not the fictively transfigured, gravity-defying "weight" of Michelangelesque anatomy; here, standing out starkly against the empty sky, Savoldo's enormously bulky illusion forces us to admit the reality of the calamity.

In its purely Lombard affirmation of the predestined coexistence of man and nature, as well as in the "artful descriptions of darkness" remarked upon by his contemporaries, Savoldo's landscape art thus leads directly to Caravaggio, however few specimens of landscape he may actually have composed or left behind. The small shafts of light that must have gleamed in the night setting of the lost original of Caravaggio's *Saint Francis Supported by an Angel* (painted around 1593) recall effects in Savoldo's *Magdalene* in London. The bits of landscape in *The Sacrifice of Isaac* (circa 1590–3) and *The Agony in the Garden* (circa 1605) are no less Savoldesque. Yet even if Caravaggio had not left behind these relics of his landscape sensibility, would we not be able to infer its character from the manner in which he paints the prison courtyard in the Malta *Beheading of John the Baptist*, or from the basket of fruit in the London version of the *Supper at Emmaus*? By the same token, would we not be able to imagine the look of Savoldo's still lifes (though he may never have painted a single one) on the basis of that same fruit basket?

That small patch of countryside in a corner of Caravaggio's [Rome] *Flight into Egypt*, deliberately "cropped" so as to let it remain fragmentary, has hitherto seemed enigmatic in its utterly unromantic, unsentimental modesty. We can recognize it now as a relic of the Lombard landscapes of a century earlier, a loving bit of naturalism added entirely for its own sake; although at the same time, with its dry brush and evergreens, its four twigs and baked rubble, it marks a trail toward the modern landscape.

Caravaggio discovers the *form of shadows*: a style in which light, no longer subservient to the plastic definition of the bodies it falls upon, has the power to decide their very existence. For the first time, the fundamental principle underlying the artist's work is no longer one of the volume of the body, but rather one of substance; an element apart from, engulfing, man, no longer man's slave. Lomazzo, for all his classicism, ventured the following abstraction: "Light is a disembodied quality." In so doing, he in a sense anticipated by three centuries the maxim of his fellow Lombard, the sculptor Medardo Rosso: "*rien n'est matériel dans l'espace.*" It is easy enough to see what a challenge this new style threw out to the bulwark erected by the wholly anthropocentric Renaissance, for which light was no more than man's characterless servant. For now light itself, and not man's conception of himself, was to become style's tool, its contrivance, its dramatic symbol. When it was some sudden shaft of light that made things real—form, *disegno*, decorum, and even magnificence of color inappropriate—things could not be anything but horribly natural. While the shadows are momentarily pierced by light, we see the even and nothing but the event: hence the inescapable naturalness I have just mentioned, its inevitable randomness, its banishment of selectivity. People and objects and settings co-exist, with no regard for any fore-ordained hierarchy of "dignities." Over the centuries, Caravaggio's precursors had already expressed this relentlessly egalitarian view of life, if less coherently than he in the charged climate of his time.

As against the grandiose, optimistic, but stop-gap solution of the classically inspired Baroque, Caravaggio's answer establishes its own bitterly true and abiding value by means of the firm, imperious accord it achieves between the physical and the metaphysical. But then, every authentic style contains (or has, at least, up through the beginning of the present century) a dialectic between naturalism and subjectivity of vision, in which supreme naturalness and supreme abstraction become interchangeable. The abrupt, abstract darkness of Caravaggio's chiaroscuro, which at first glance seems to express nothing more than a tragic, primordial cataclysm of light and shadow, suddenly discloses, as if by fateful accident, the most tangible, natural, *lived* events ever imagined or expressed.

This is at once the final outcome of the older Lombard order and the beginning of a new order: an event not so much Italian as European. The new art passes undistracted by the old Baroque giant, who sleeps an agitated, vaporous sleep; sure of the way, it emerges on the other side, where it joins up with the great achievements of modernity.

The road may be torturous, but it does lead all the way from the horse who is the true protagonist of *The Conversion of Saint Paul* to the *Umbrellas* that constitute the real subject of Renoir's famous picture. Or to put in more stylistical, genealogical terms: when Rubens, to amuse himself, enters the Chiesa Nuova [in Rome] and copies Caravaggio's *Entombment* he twists and distorts it in every way possible, as befits a Baroque Sisyphus. But three centuries later, when Cézanne copies the same work in order to learn from it, he reveals, with incredible insight, its quintessential, abstract, metaphysical aspect. There could be no better demonstration that there is indeed a shell of idealism enclosing the awesome naturalness of Caravaggio, the last of the "Lombards."

Concise Bibliography

Askew, Pamela. *Caravaggio's Death of the Virgin*. Princeton: Princeton University Press, 1990.

Bal, Mieke. *Quoting Caravaggio: Contemporary Art, Preposterous History*. Chicago: University of Chicago Press, 1999.

Berenson, Bernard. *Caravaggio: His Incongruity and His Fame.* London: Chapman & Hall, 1953.

Bayer, Andrea. *Painters of Reality: The Legacy of Leonardo and Caravaggio in Lombardy*. New York: Metropolitan Museum of Art, 2004.

Burckhardt, Jacob. *The Cicerone*. London: John Murray, 1873.

Christiansen, Keith. *A Caravaggio Rediscovered: The Lute Player*. New York: Metropolitan Museum of Art, 1990.

Friedlaender, Walter F. *Caravaggio Studies*. New York: Schocken Books, 1969.

Hibbard, Howard. *Caravaggio*. New York: Harper & Row, 1983.

Hunt, Patrick. *Caravaggio*. London: Haus Publishers, 2004.

Kitson, Michael. *The Complete Paintings of Caravaggio*. New York: Harry N. Abrams, 1969.

Langdon, Helen. *Caravaggio: A Life*. London: Chatto & Windus, 1998.

Longhi, Roberto. *Three Studies*. Riverdale-on-Hudson: The Sheep Meadow Press, 1995.

Moffitt, John F. *Caravaggio in Context: Learned Naturalism and Renaissance Humanism*. Jefferson: McFarland & Co., 2004.

Mormando, Franco. *Saints & Sinners: Caravaggio & the Baroque Image*. Chestnut Hill: McMullen Museum of Art, Boston College, 1999.

Puglisi, Catherine R. *Caravaggio*. London: Phaidon, 1998.

Robb, Peter. *M: The Man Who Became Caravaggio*. New York: Henry Holt and Company, 2000.

Spear, Richard E. *From Caravaggio to Artemisia: Essays on Painting in Seventeenth-Century Italy and France*. London: Pindar Press, 2002.

Wilson-Smith, Timothy. *Caravaggio*. London: Phaidon, 1998.